Beautiful Creatures 2

The Art of James Ryman

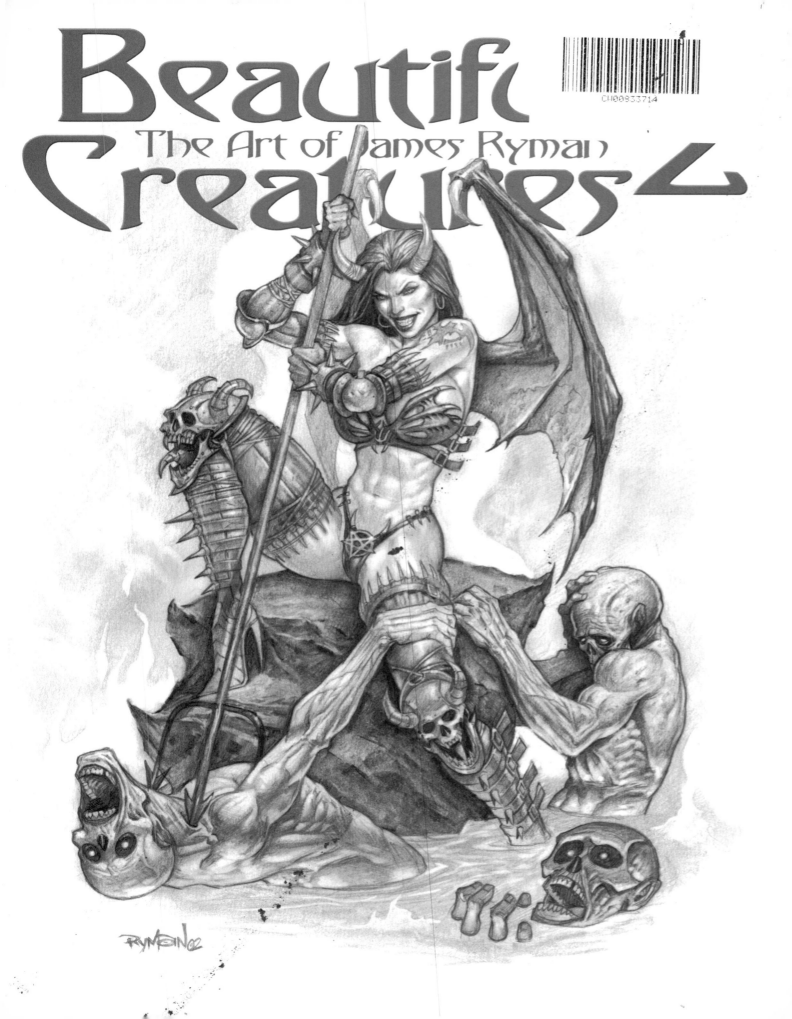

James Ryman - Devilishly Good!

Since the first volume of Beautiful Creatures I've made a few changes, some of which you'll see reflected in this book. A lot of the work here is the result of being involved with fantasy Role Playing Games (RPG's). I must confess to not ever having played myself, but the opportunity to create work for that industry has led to many hours of fun at the drawing board, and the chance to meet and work with some terrific people.

I'm also no longer working full time in video games. The need, or I should say the compulsion, to make pictures finally got the better of me. And I'm happy about it too! The solitary nature of painting and drawing is a refreshing change from the team driven environment of developing a video game. Not needing to go into an office to work is great, but I do need to get better at scheduling my time. Marker pens in hand I draw and write all over the calendar that hangs on my wall, assigning time to projects, forgetting to give myself any days off.

Another significant change is that my wife and I are currently planning our move back to England. After 7 and a half years in sunny California, it's back to not-quite-so-sunny Nuneaton, in the Midlands. We've both made friends here and had a great time, and we plan on returning to visit, and to attend conventions and the like. We have both missed family back home for a while now, although it may escape me as to why after I've been back there for a year or so.
Just kidding. My family is fine. Really.

So here's hoping that the third and final volume of Beautiful Creatures won't take quite as long to make. I'd like to blame it on the publisher, or God, or the neighbors, but I really can't. I took my sweet time collecting the work, and I thank Sal and Bob for putting this volume together for me.

My wife Lynne continues to put up with me, and all of the drawings of naked chicks and monstrous beasties. She also brings me beer. Cool.

BEAUTIFUL CREATURES
THE ART OF JAMES RYMAN
Volume Two

All artwork is copyright © 2004 James Ryman.
Beautiful Creatures-The Art of James Ryman Volume Two
© 2004 S.Q. Productions Inc.
All rights reserved. Printed in the United States.
Book design by Grassy Knoll Studios.
Publishers: Sal Quartuccio and Bob Keenan

Published by
SQP Inc.
PO Box 248 - Columbus, NJ 08022

For 30 years, celebrating the best of fantasy, erotic, & pin-up artwork.
To access our library of available titles, or to order a free catalog, go to:

www.sqpinc.com

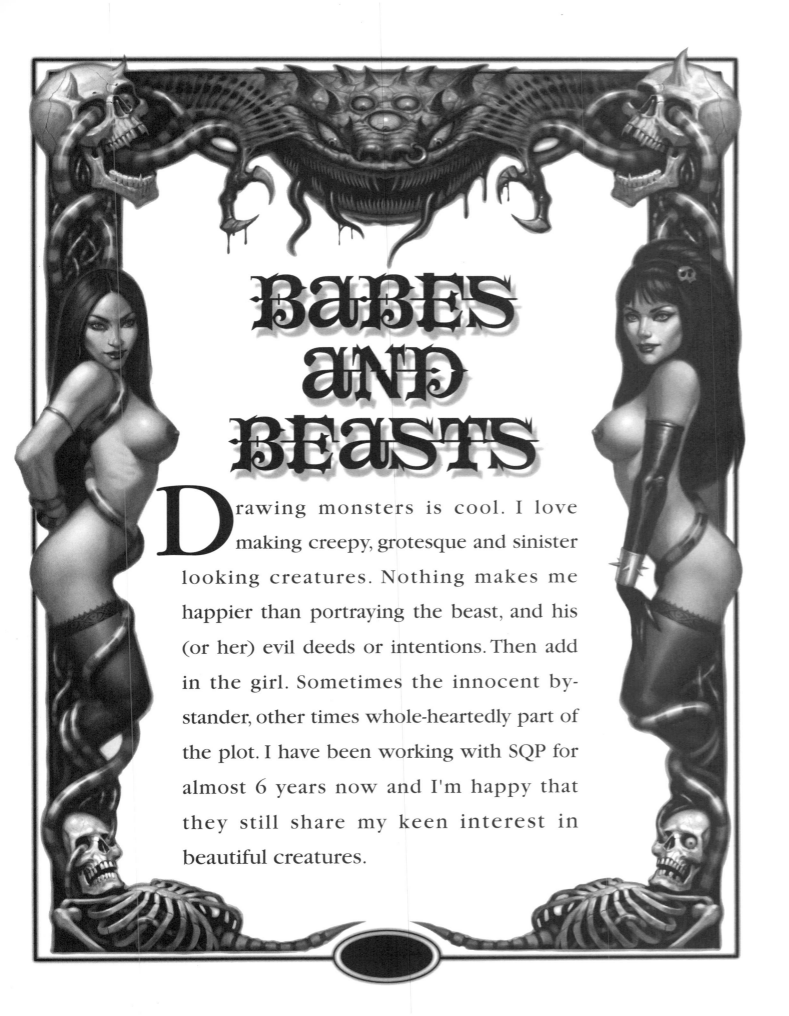

BABES AND BEASTS

Drawing monsters is cool. I love making creepy, grotesque and sinister looking creatures. Nothing makes me happier than portraying the beast, and his (or her) evil deeds or intentions. Then add in the girl. Sometimes the innocent by-stander, other times whole-heartedly part of the plot. I have been working with SQP for almost 6 years now and I'm happy that they still share my keen interest in beautiful creatures.

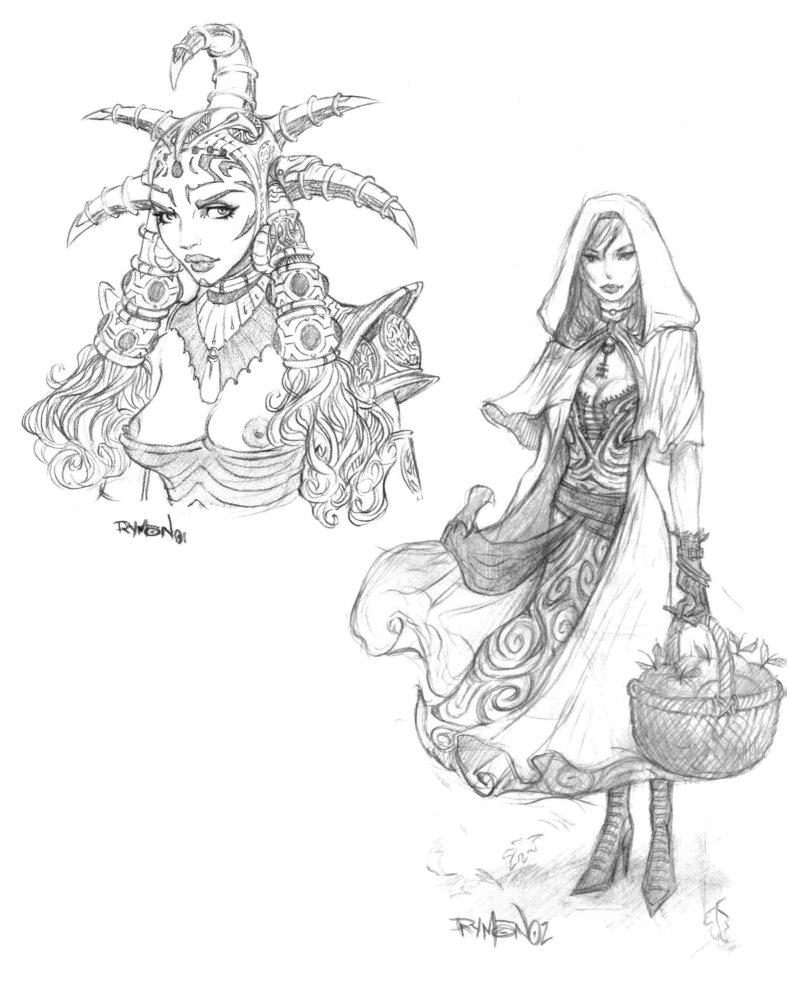

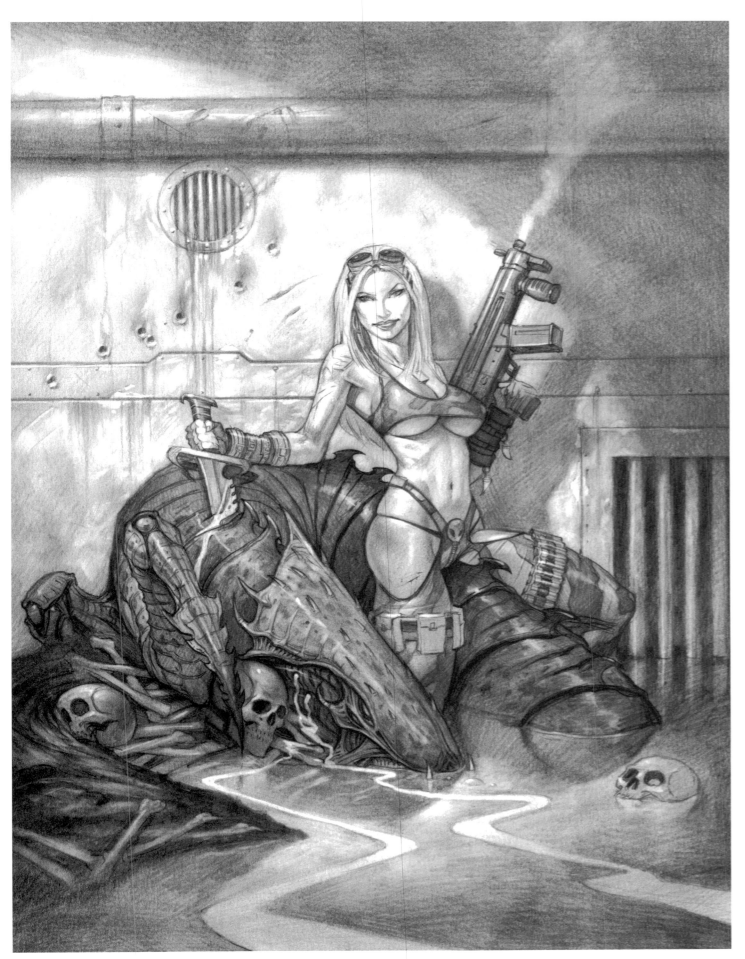

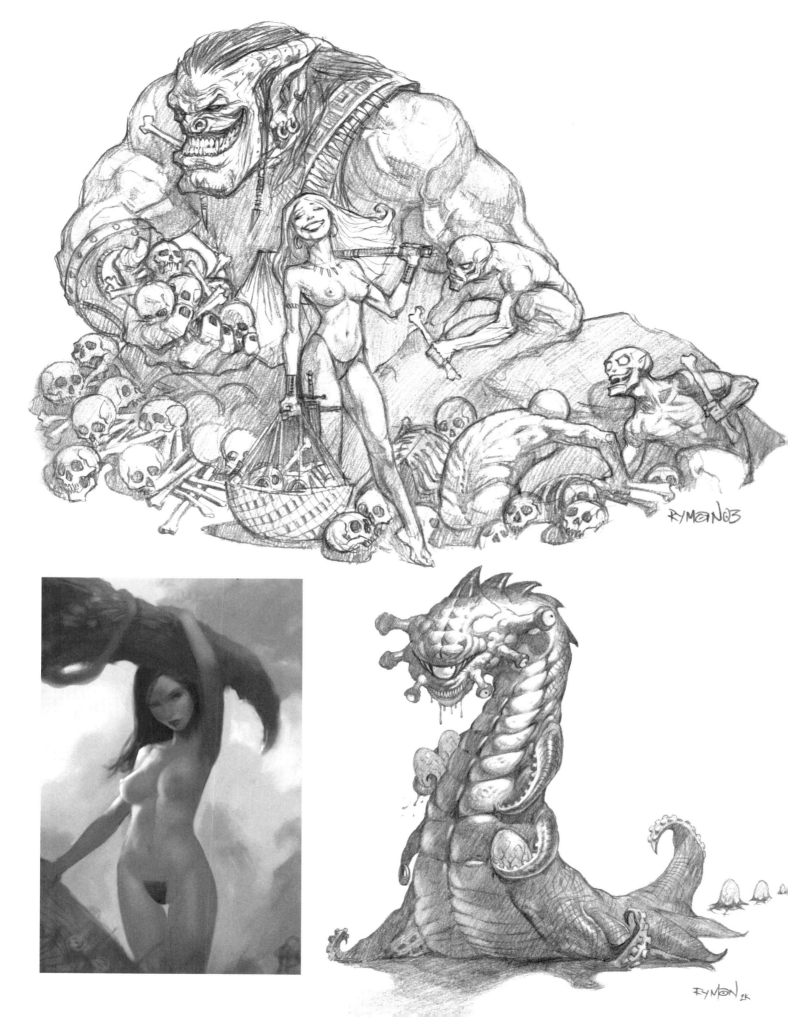

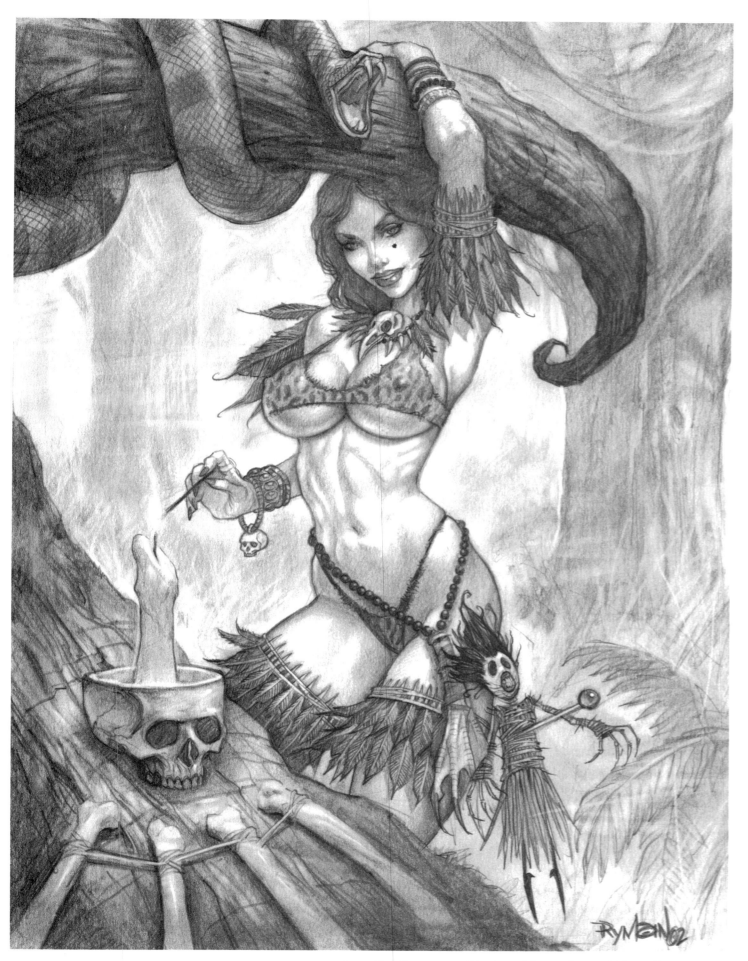

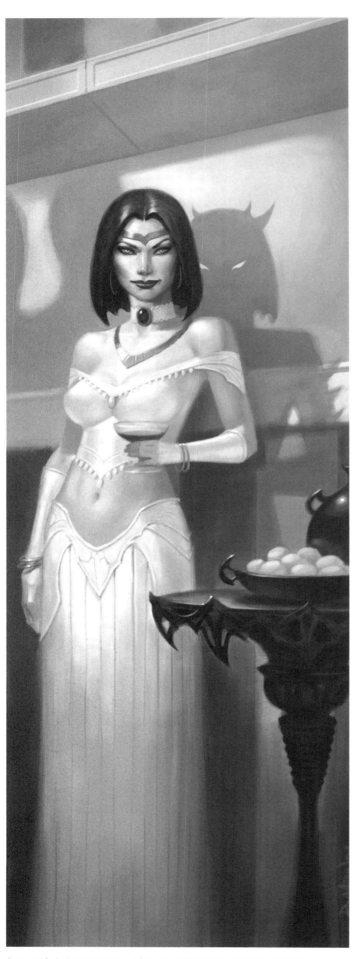
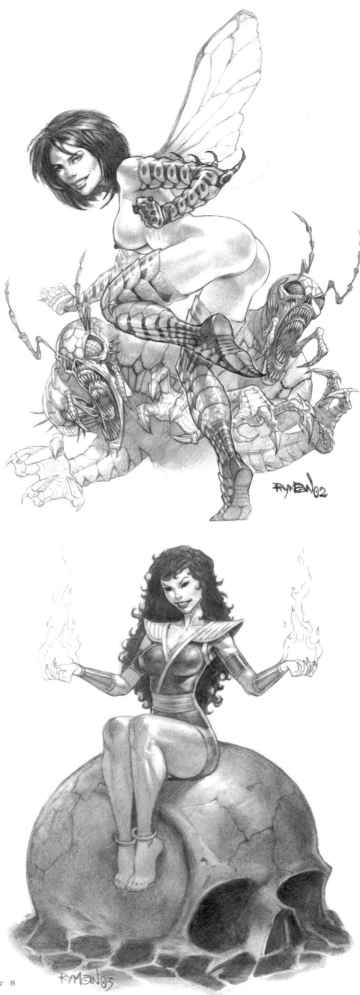

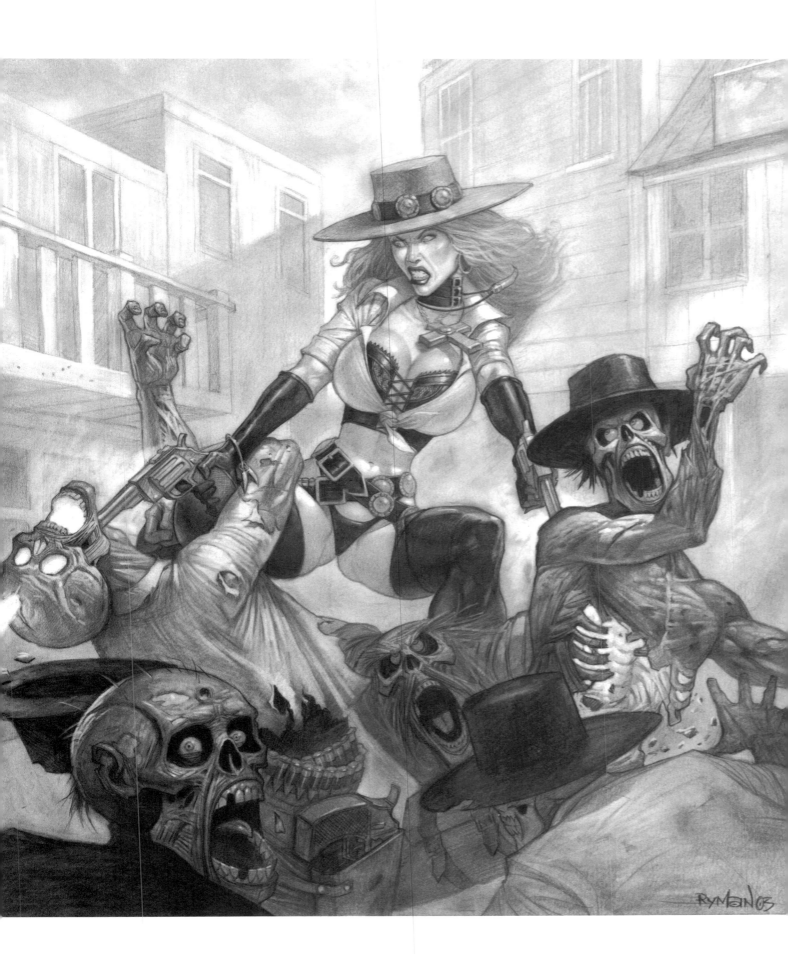

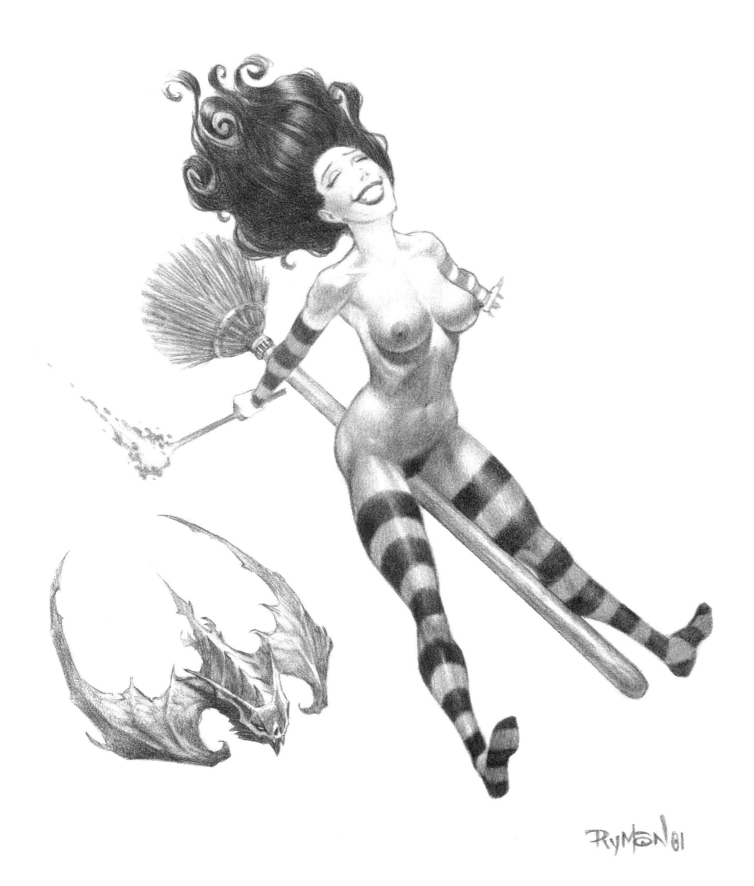

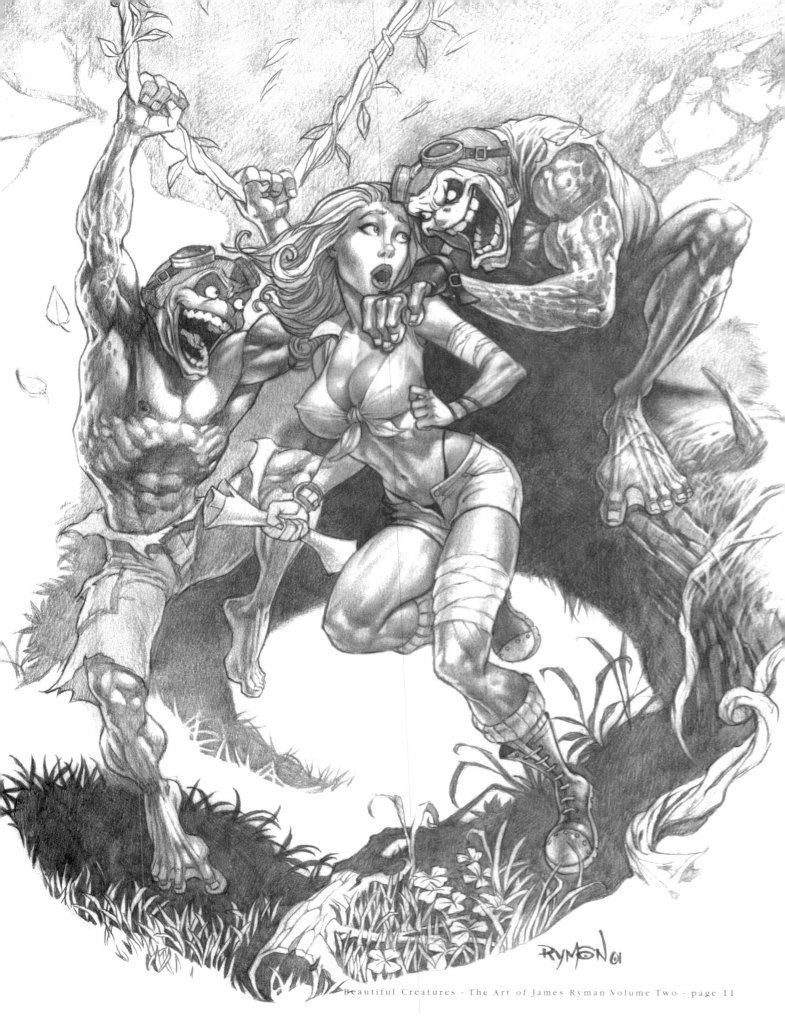

RYMAN 01

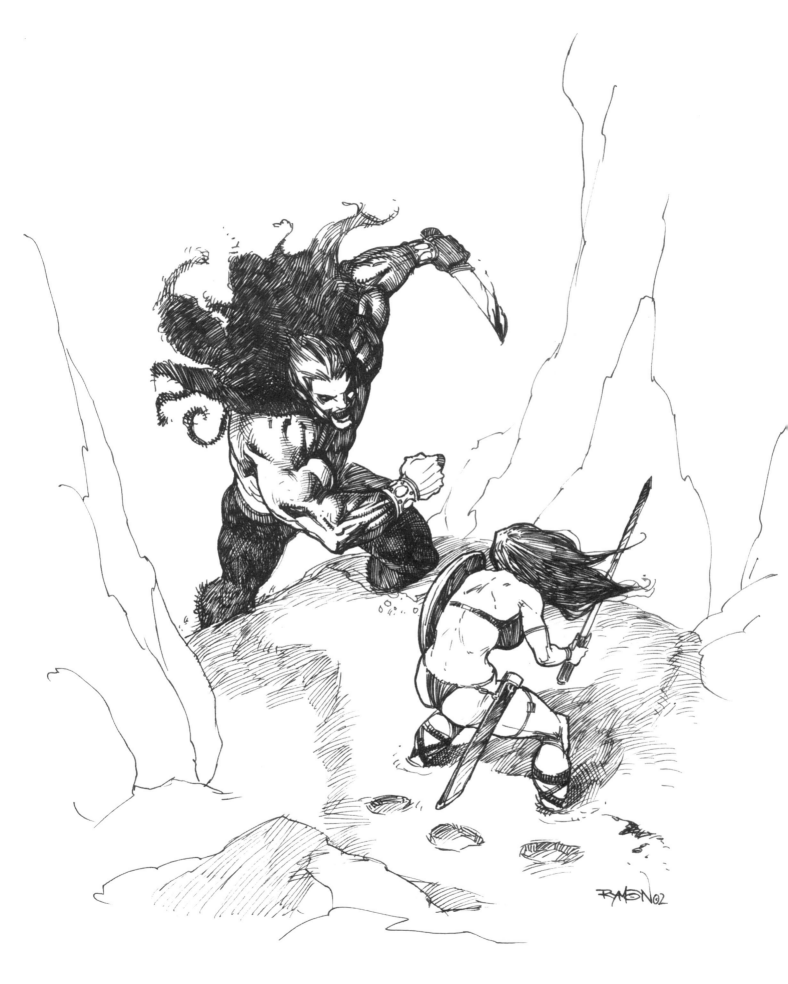

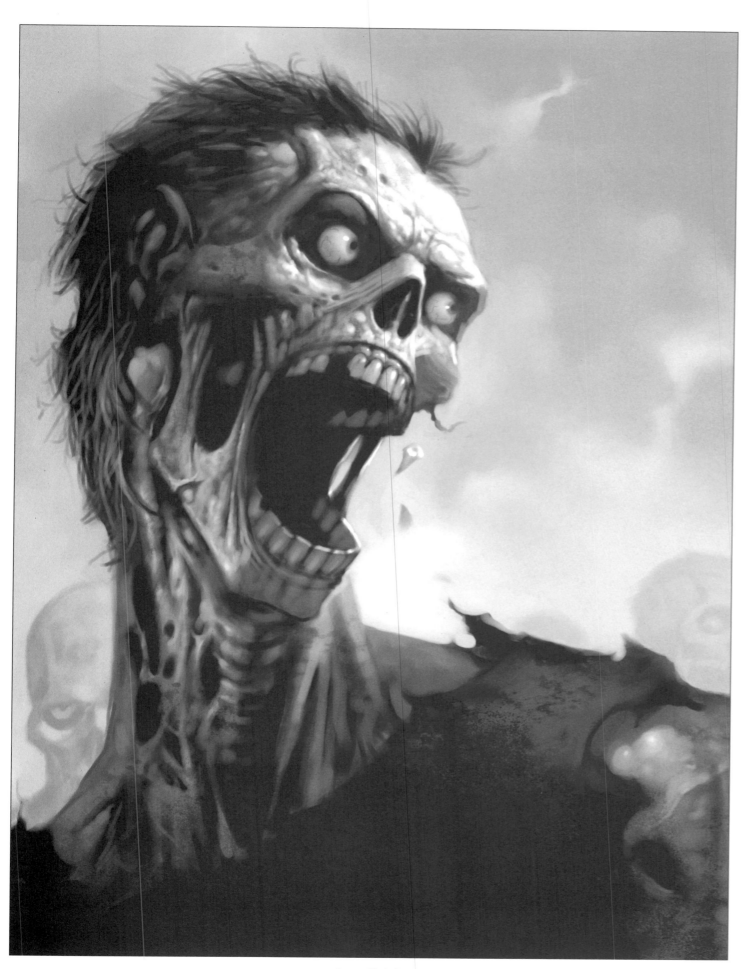

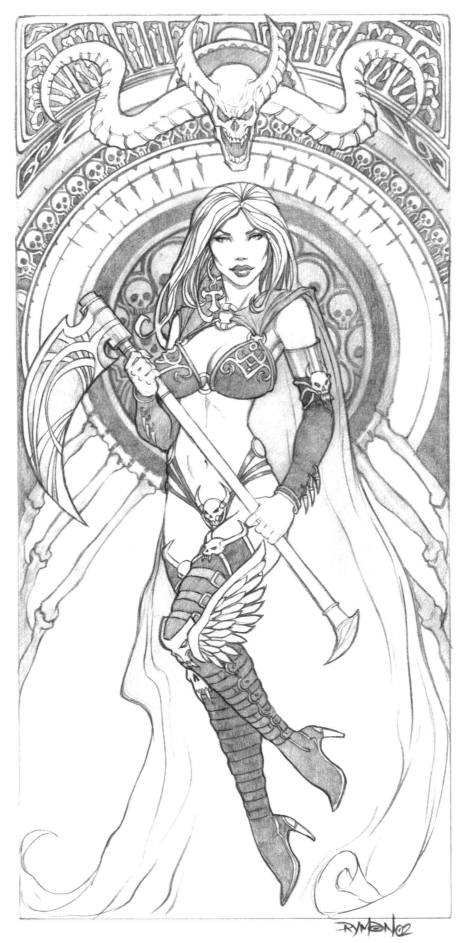

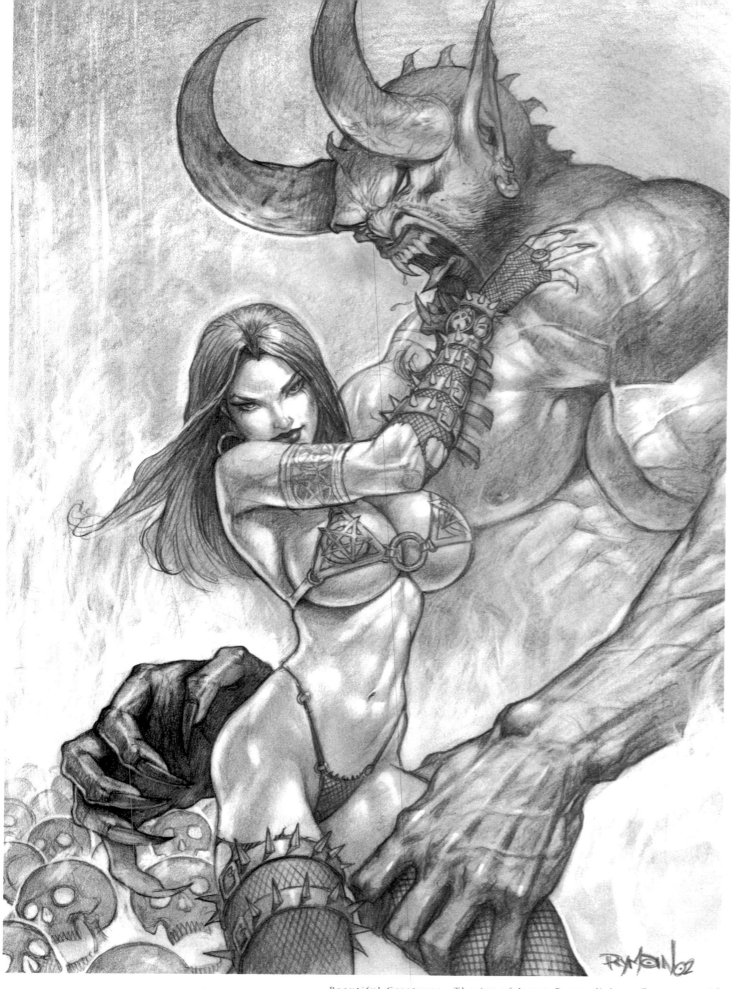

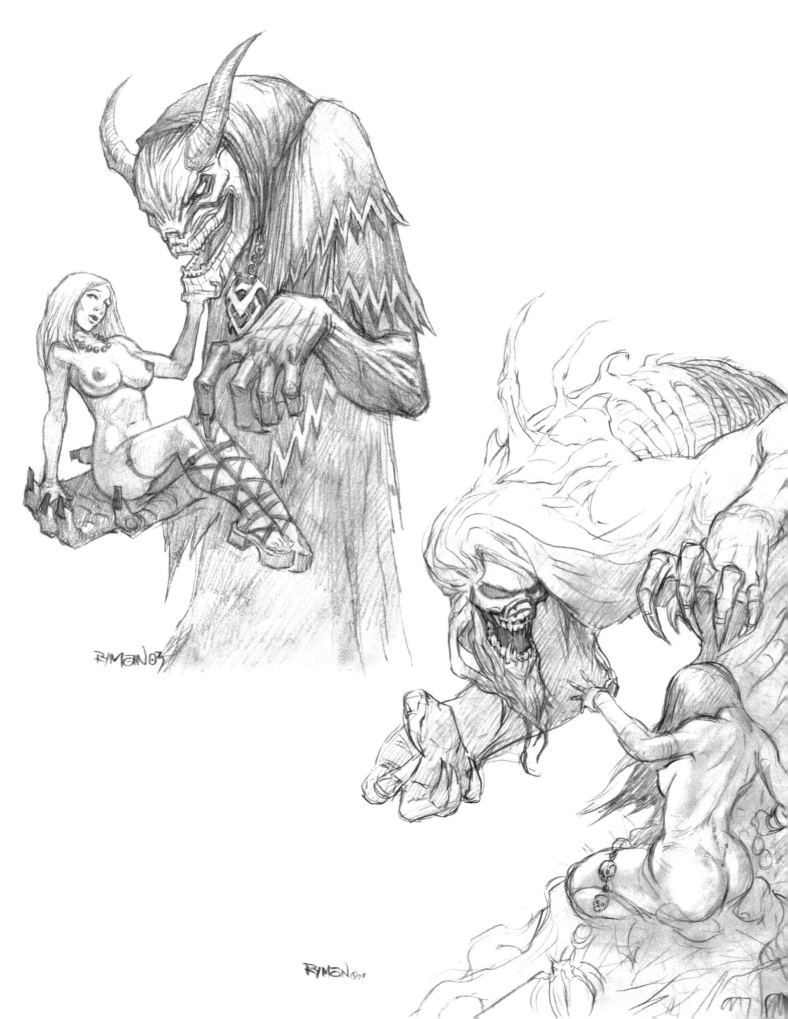

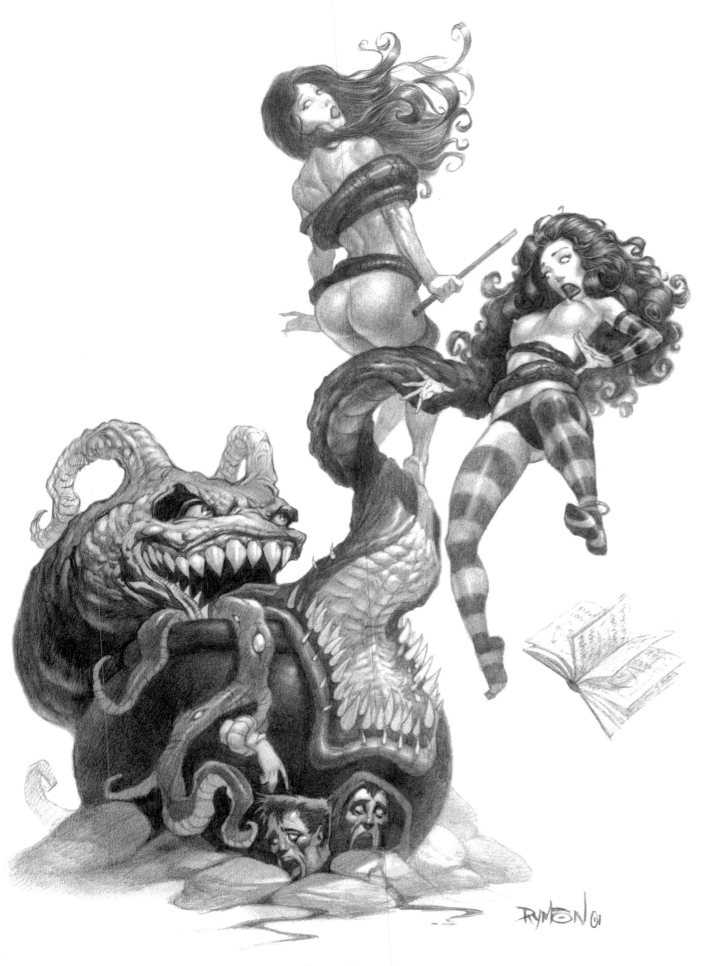

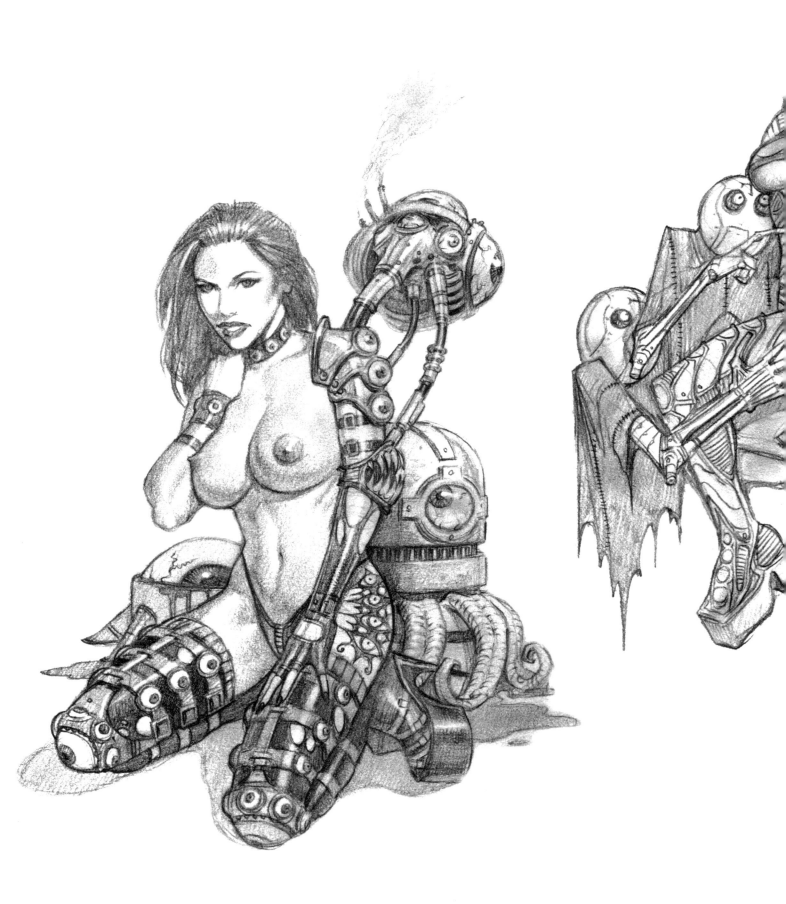

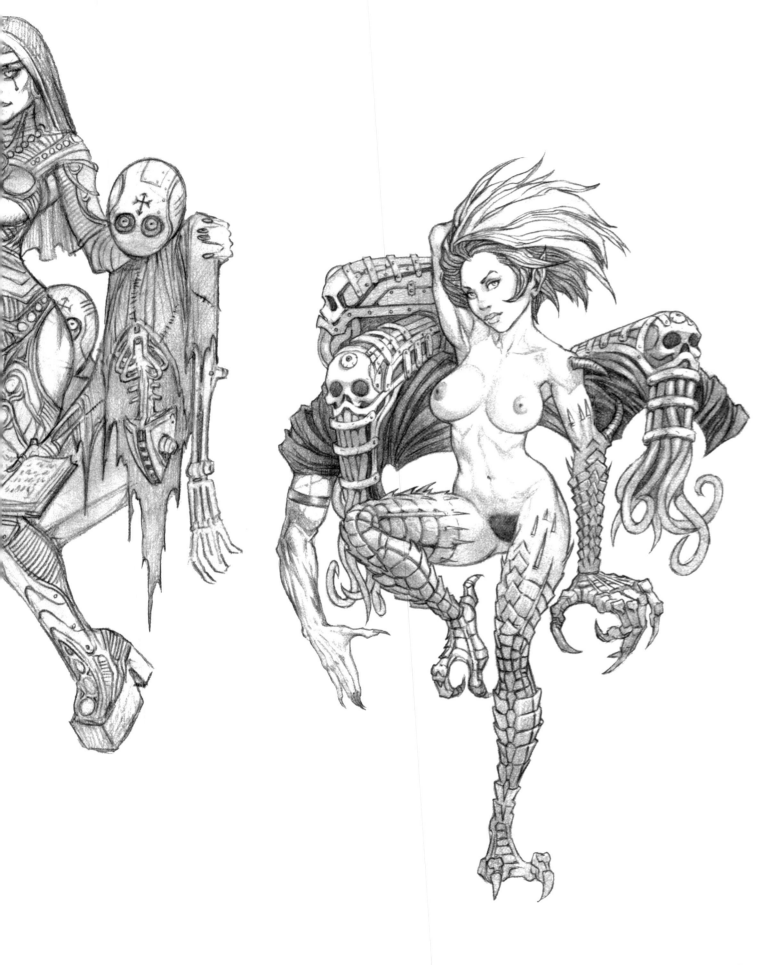

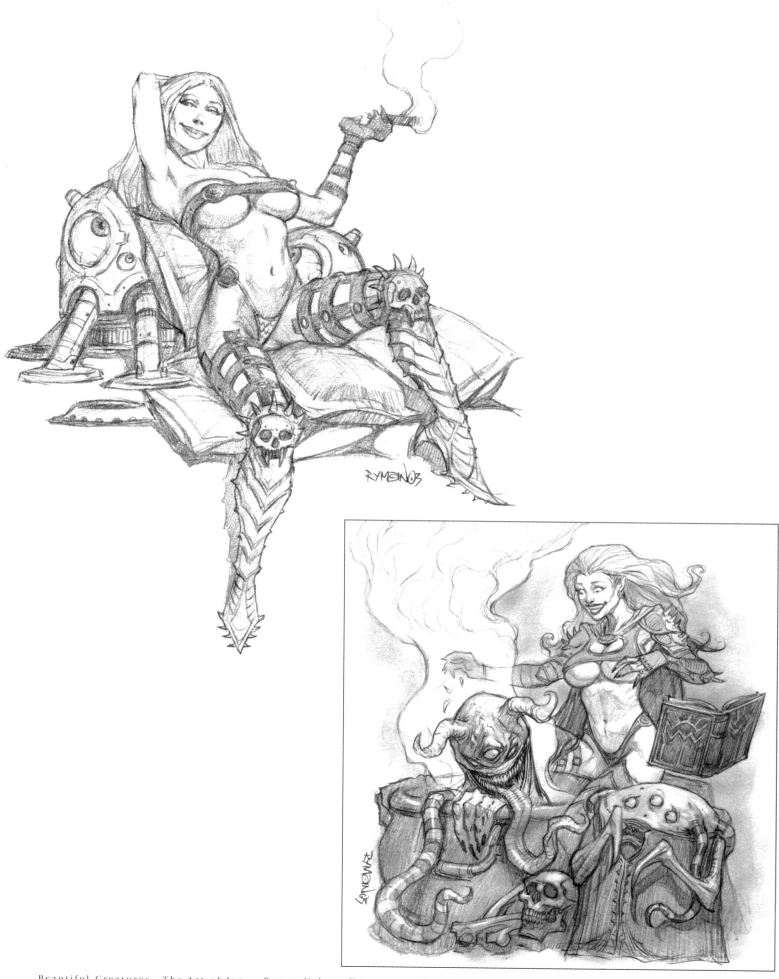

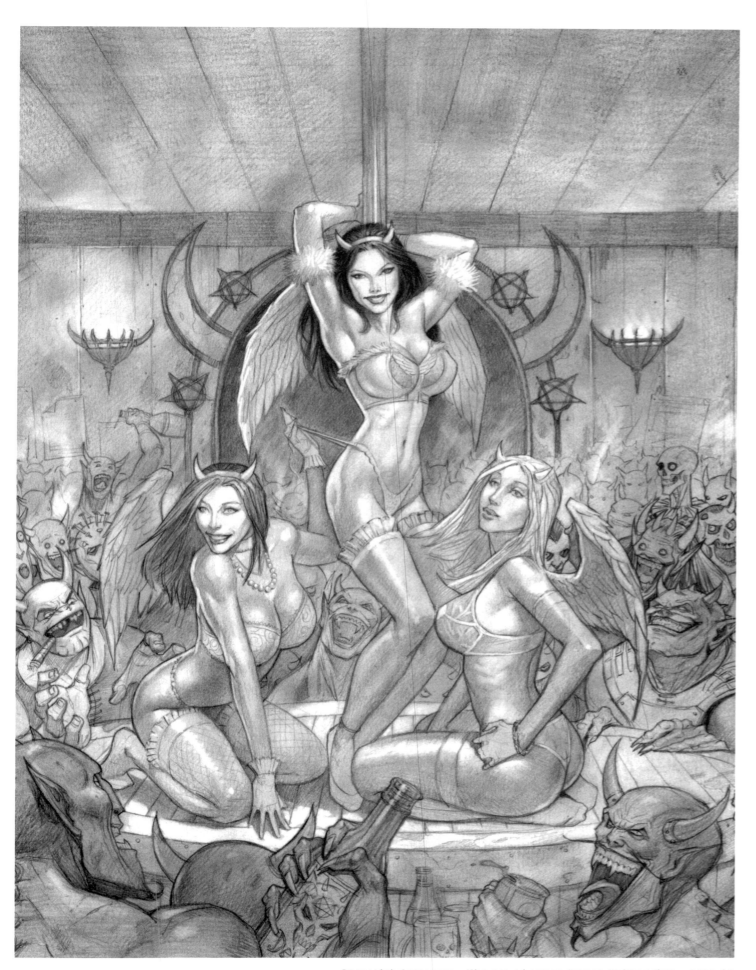

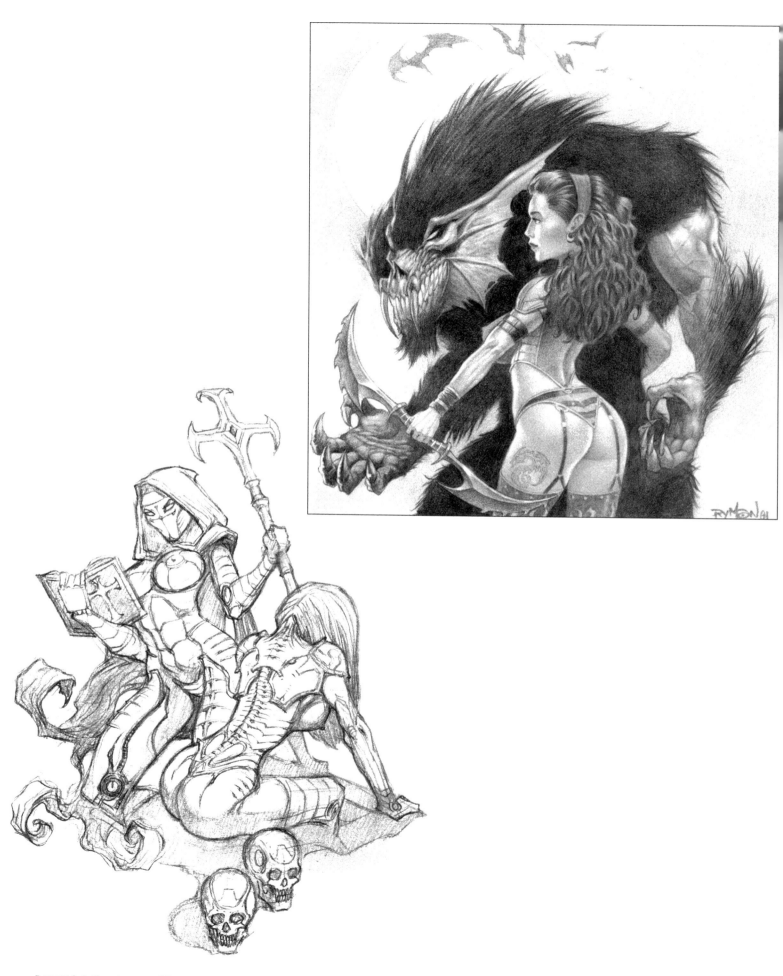

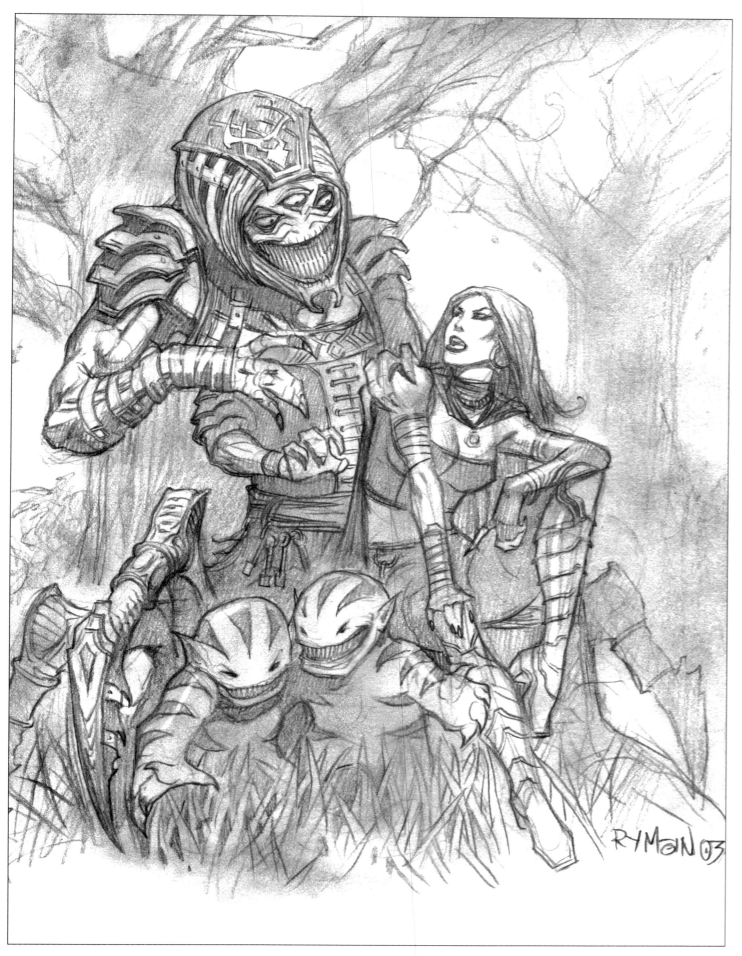

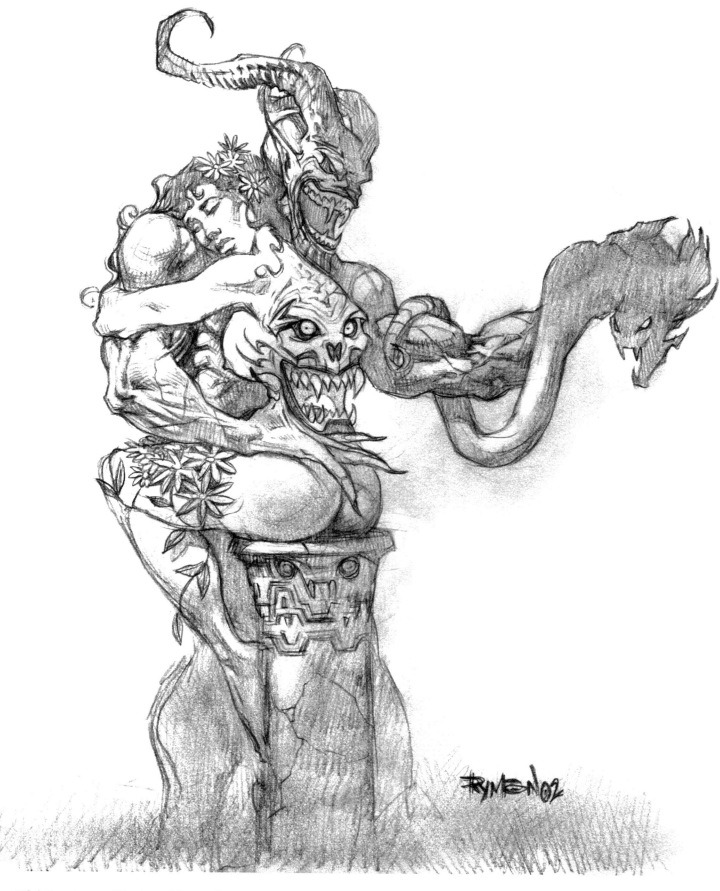

Fantasy

Over the past couple of years I have been working in the Fantasy Role Playing Game industry. I was very fortunate to find Green Ronin Publishing (www. greenronin.com) to kick off in this field. Since then I have worked for Dragon Magazine, Dungeon/Polyhedron Magazine, along with Fantasy Flight games, ICE games, Privateer Press and Hero Games. Nearly all of the character work starts with a written description provided by the publisher, which I then get to interpret and sometimes expand upon. Again, I always look forward to the villains, the demons, all of that lovely evil stuff!

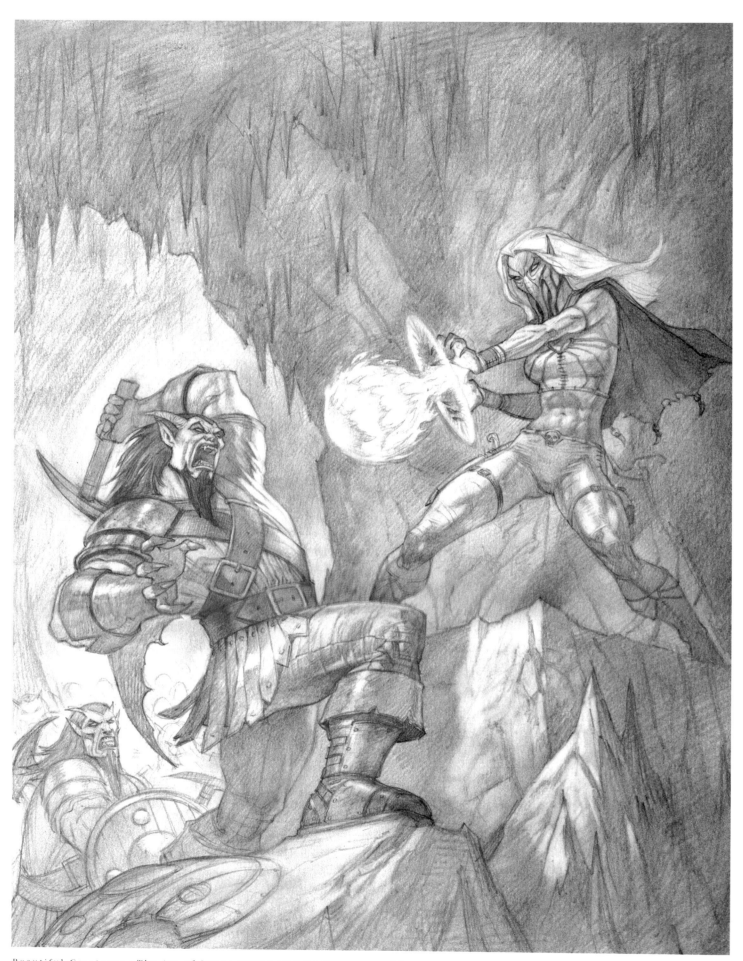

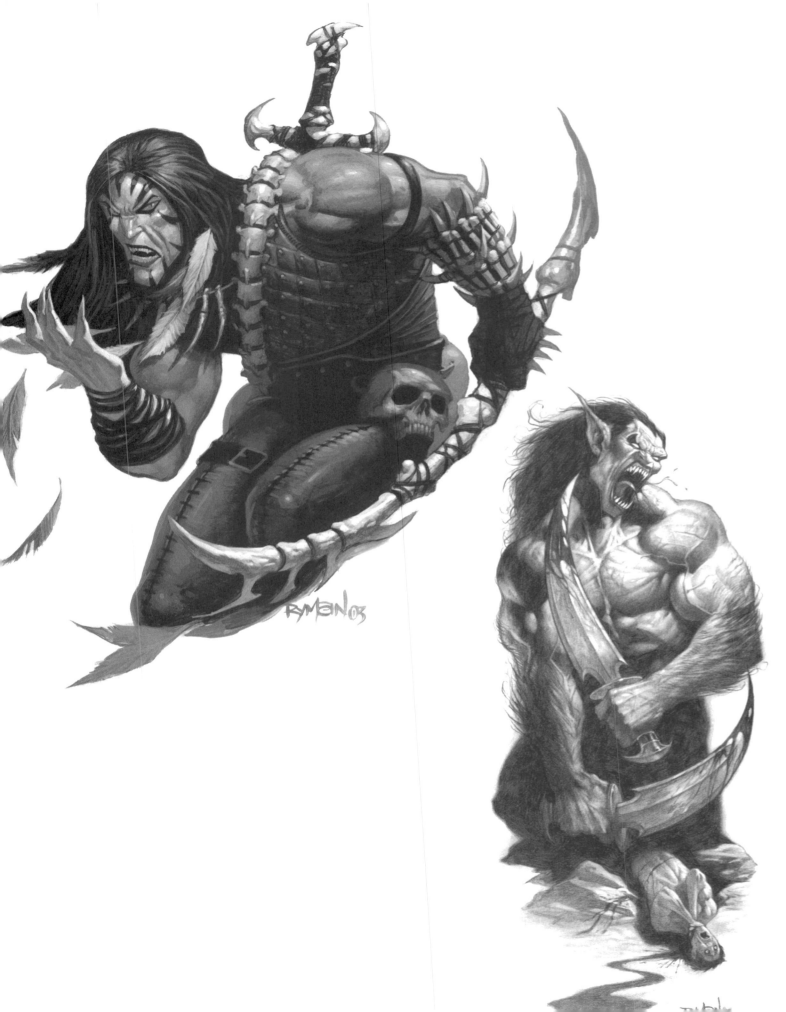

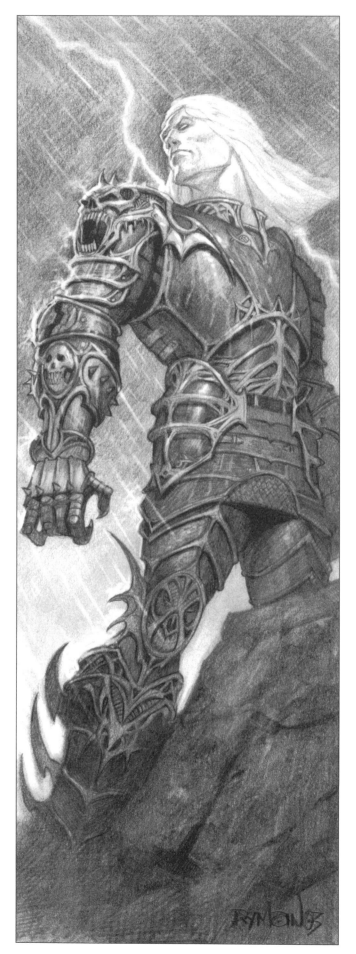

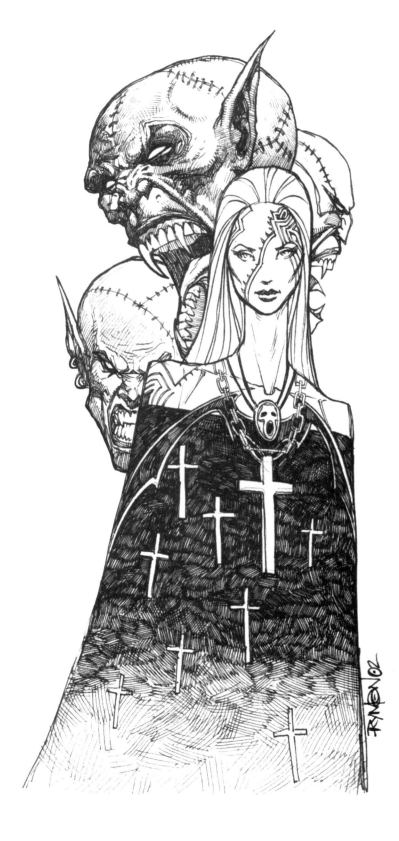

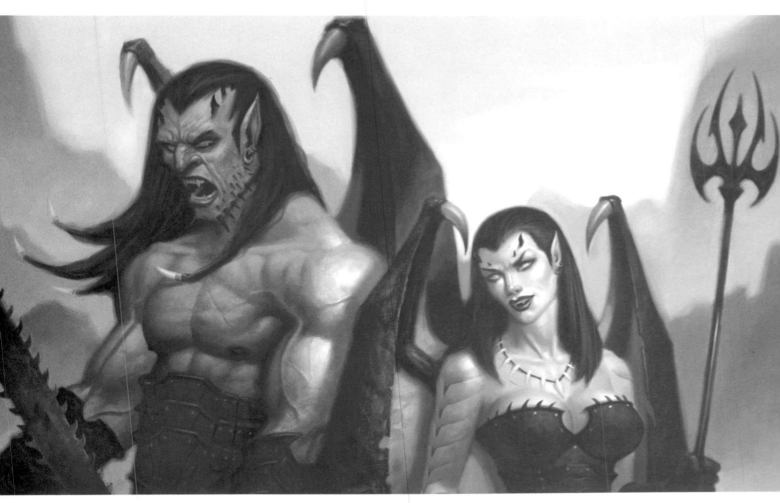

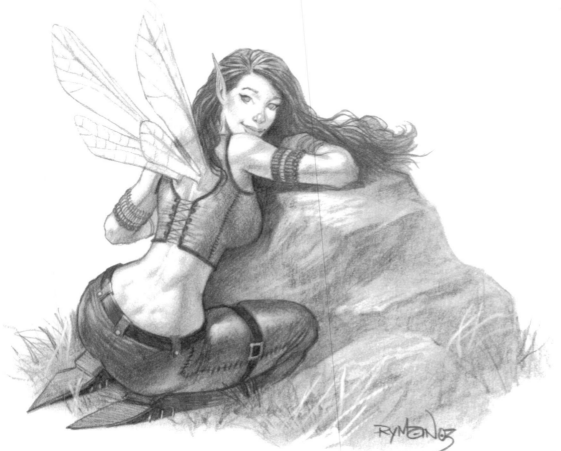

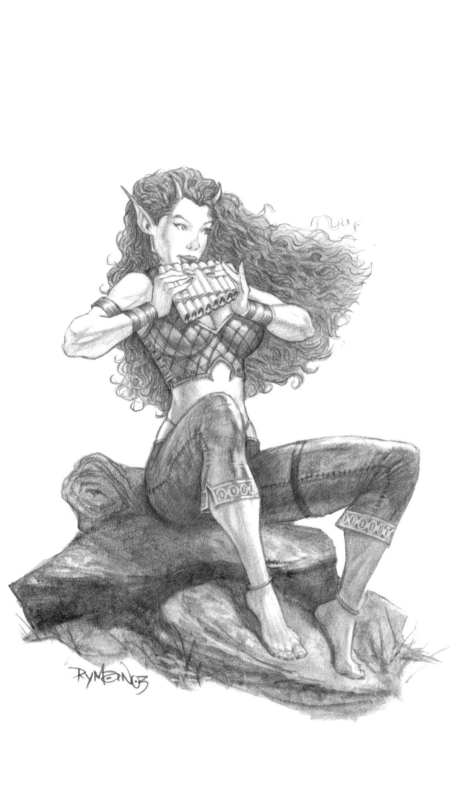
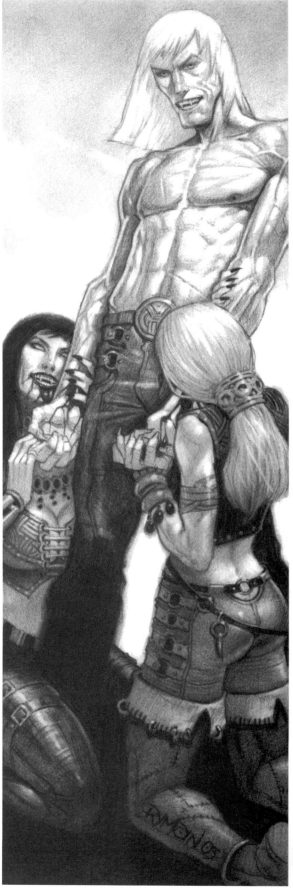

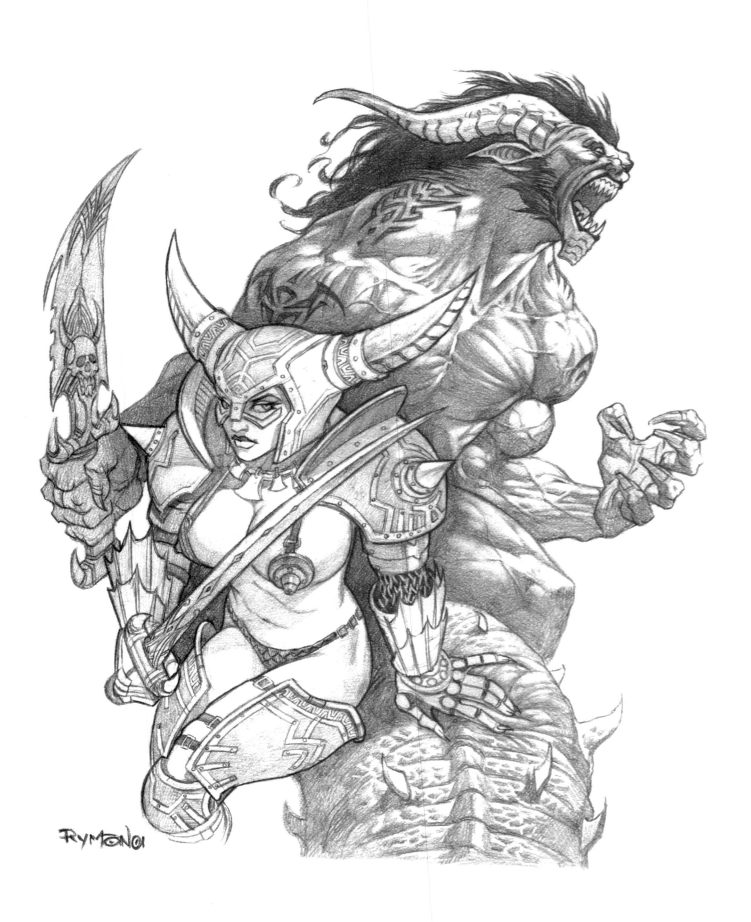

RyMoN01

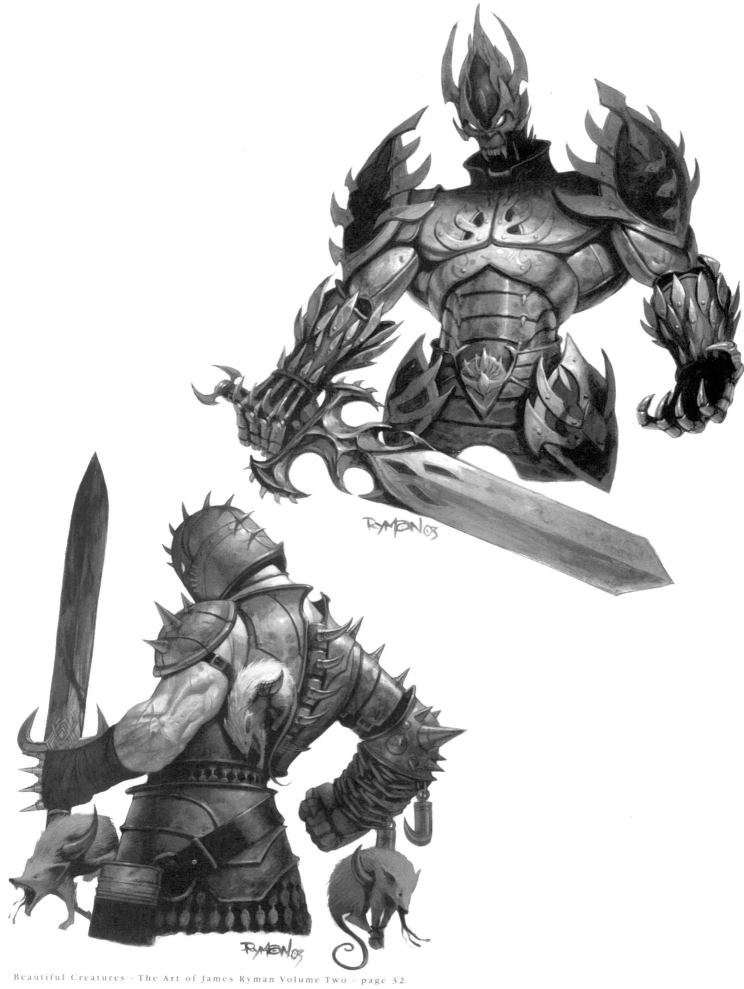

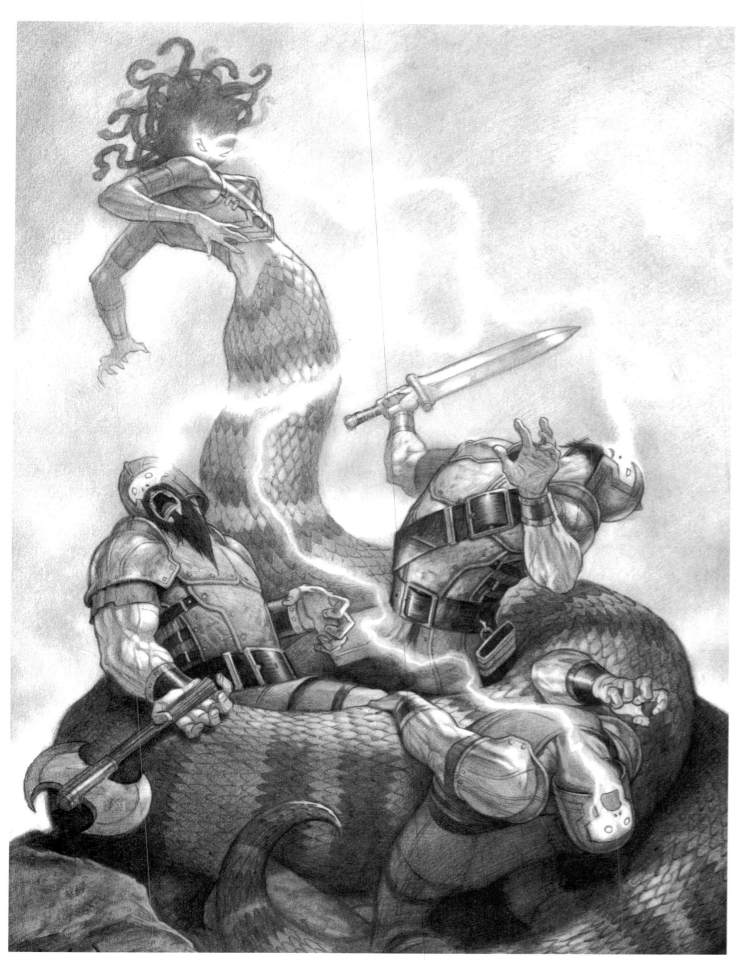

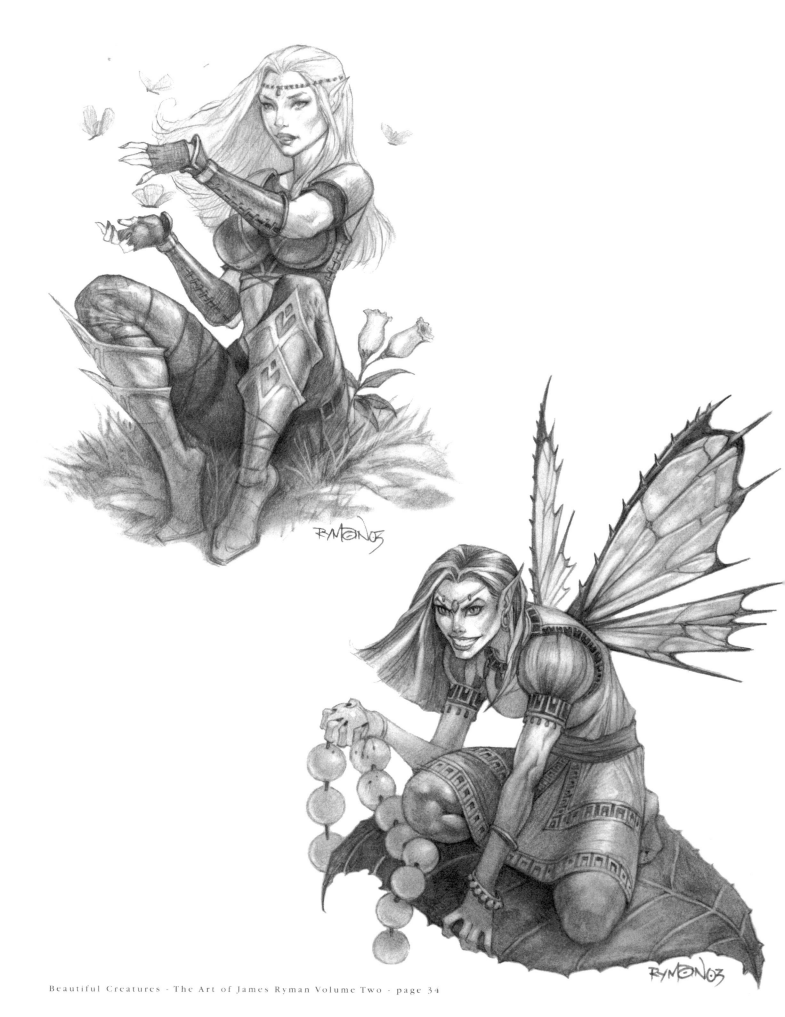

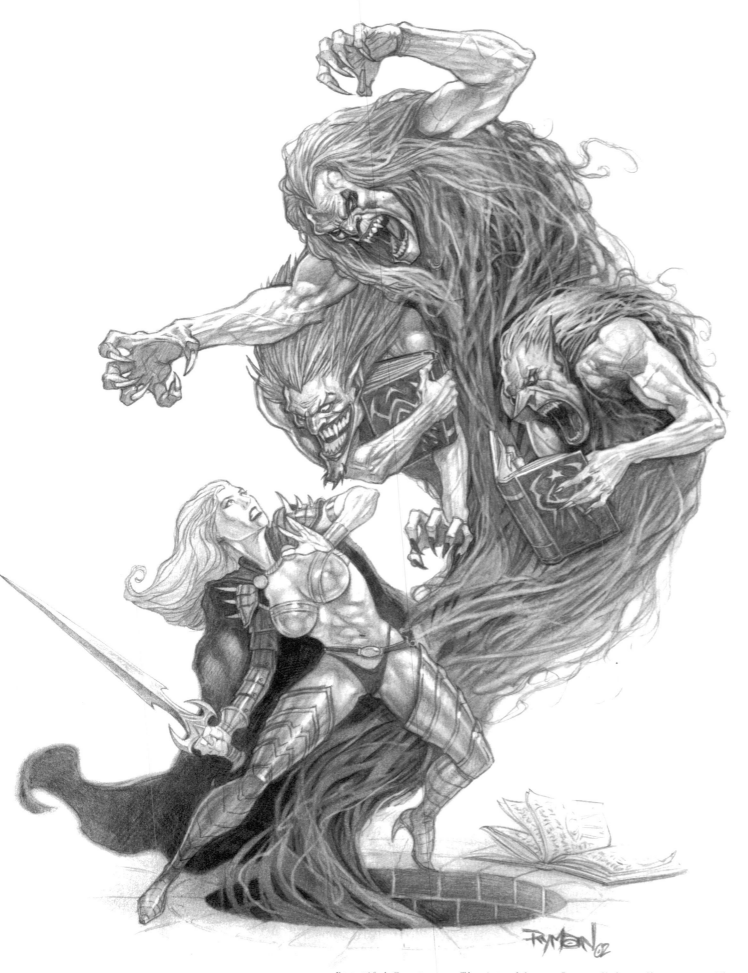

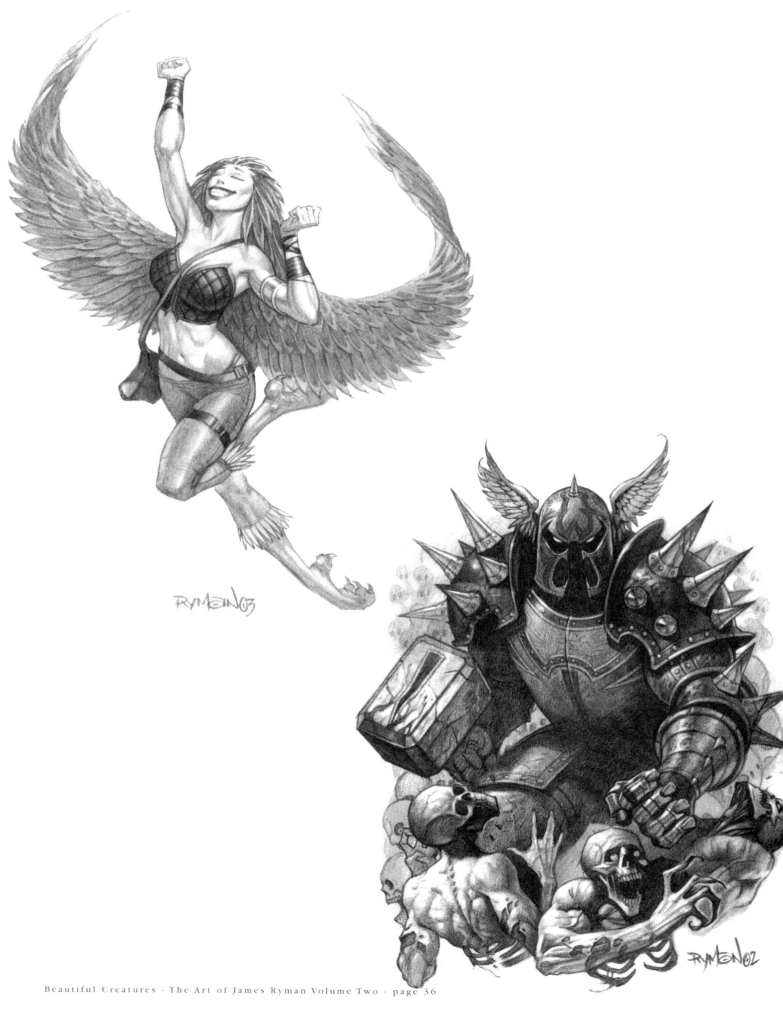

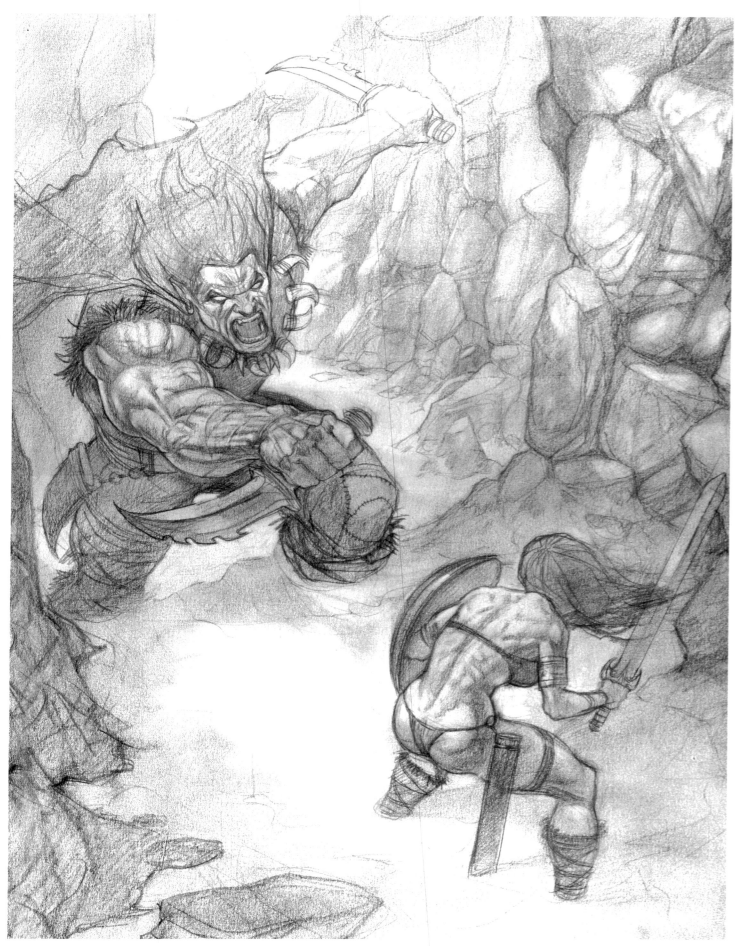

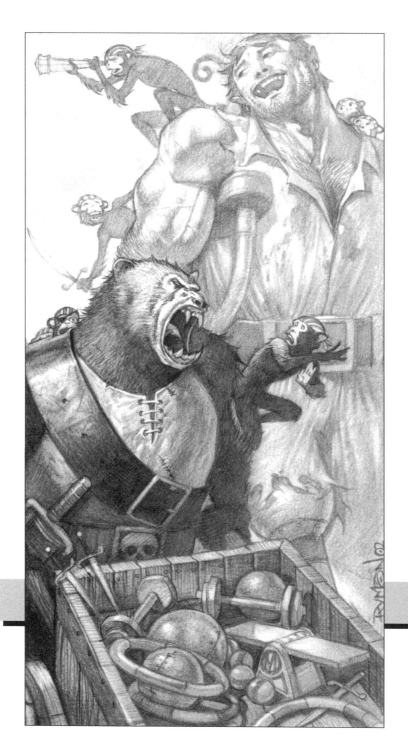

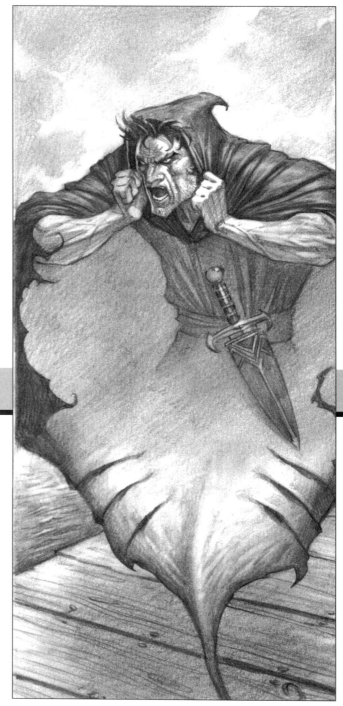

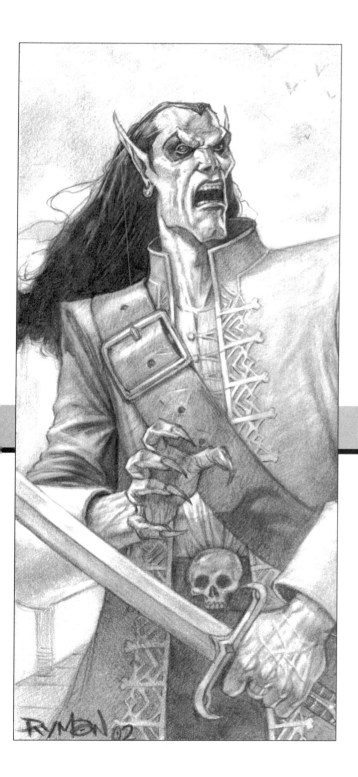

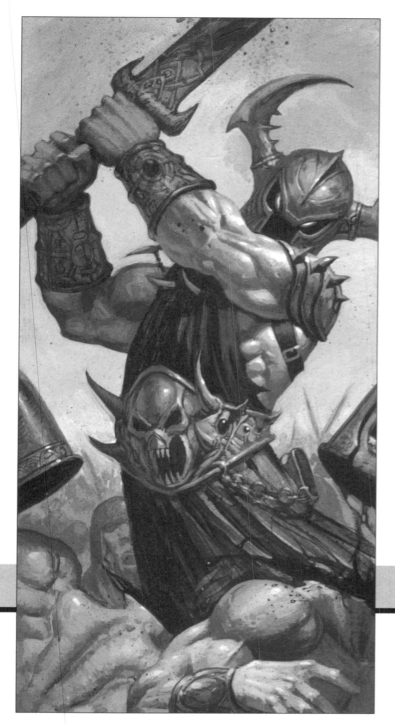

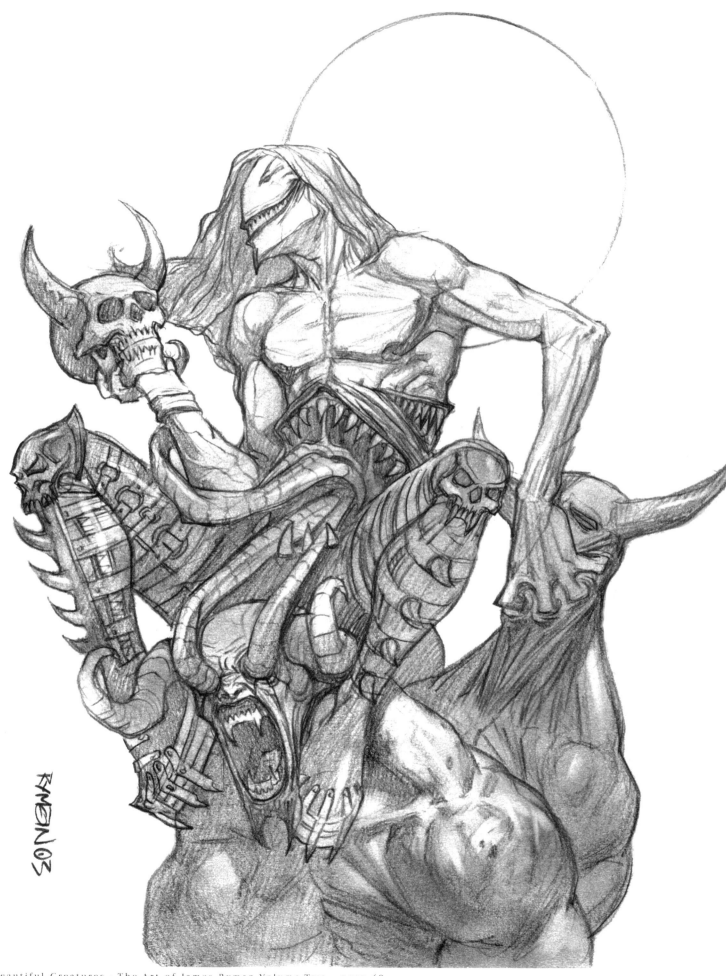

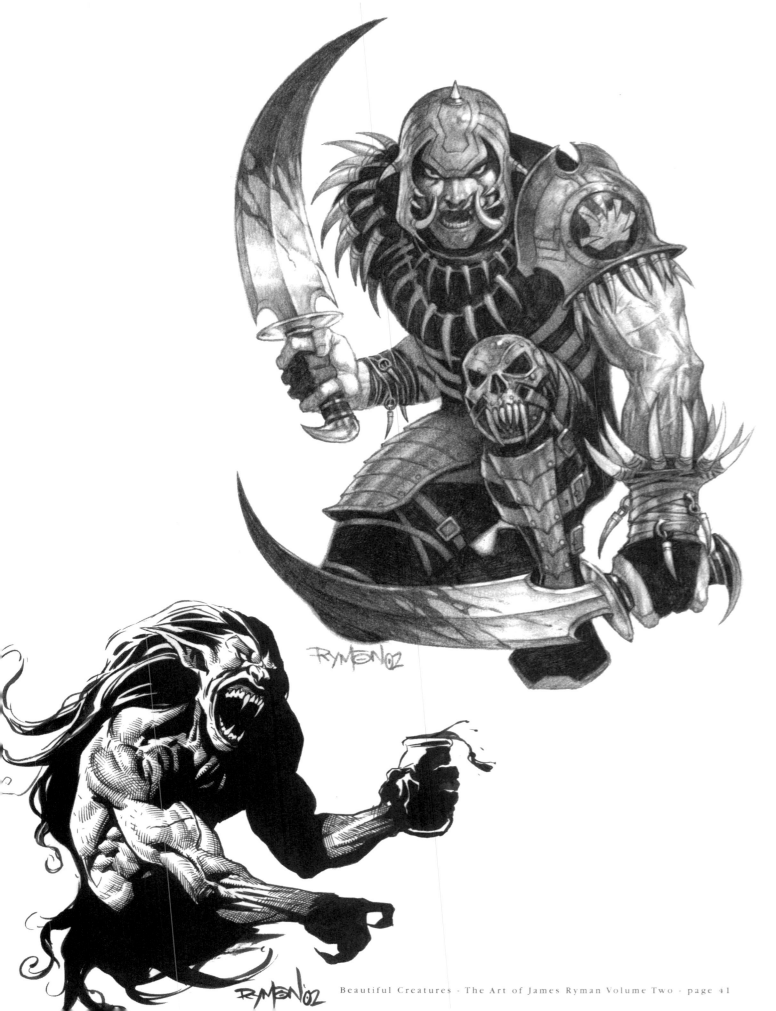

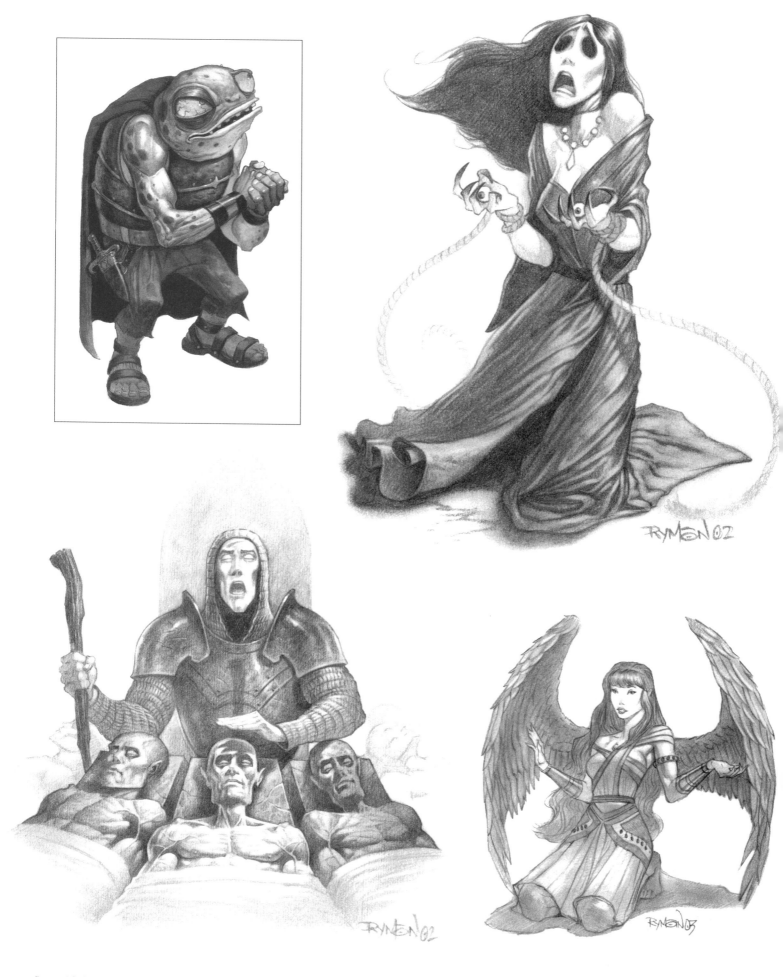

TOONS

Now and then I like to do something a bit different. It's fun at times not to have to worry too much about tons of detail and rendering and get straight to the pose and attitude. Toons allow me to draw quickly and get to the finished image in a shorter amount of time than a finished pencil drawing would. But even in my Toonland, babes and beasts are still the order of the day!

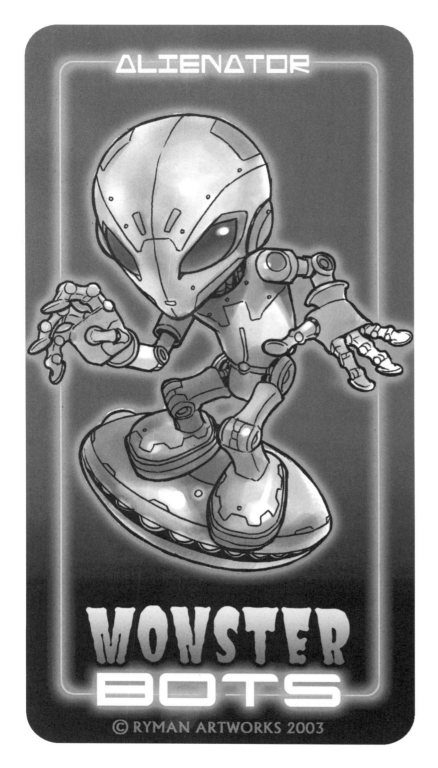

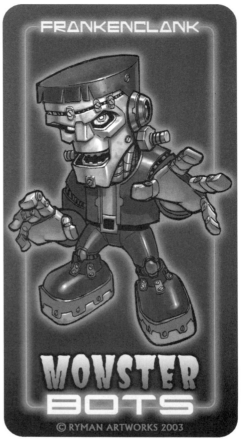

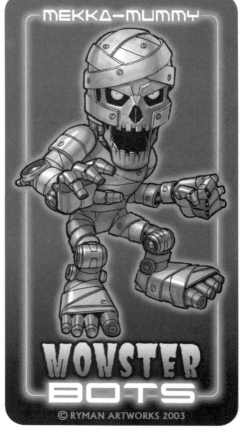

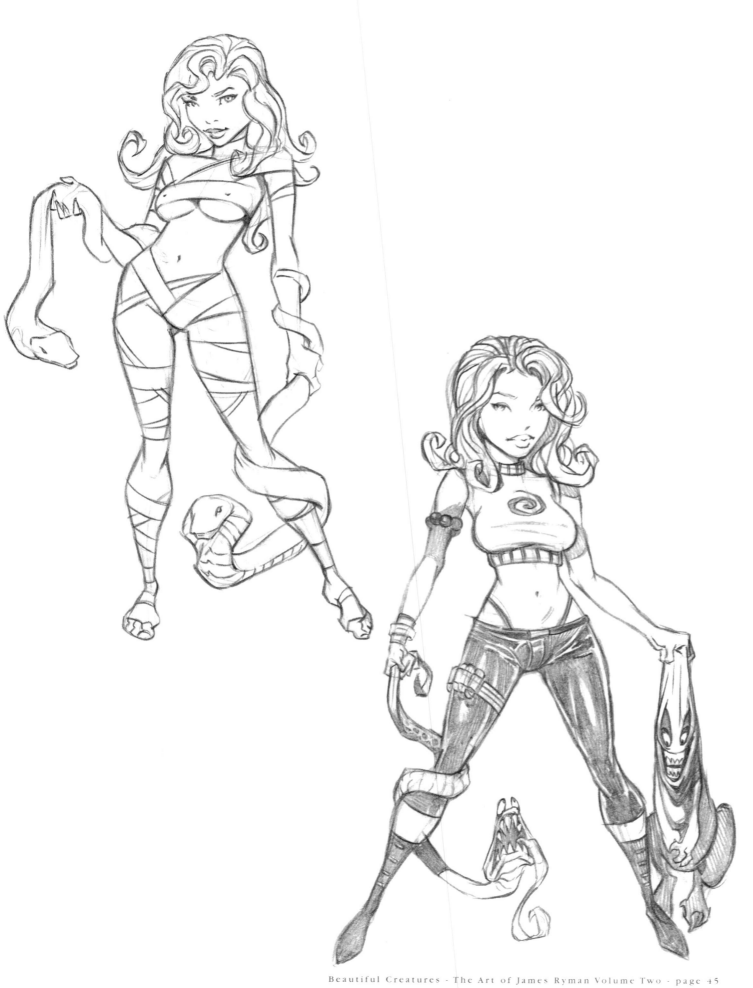

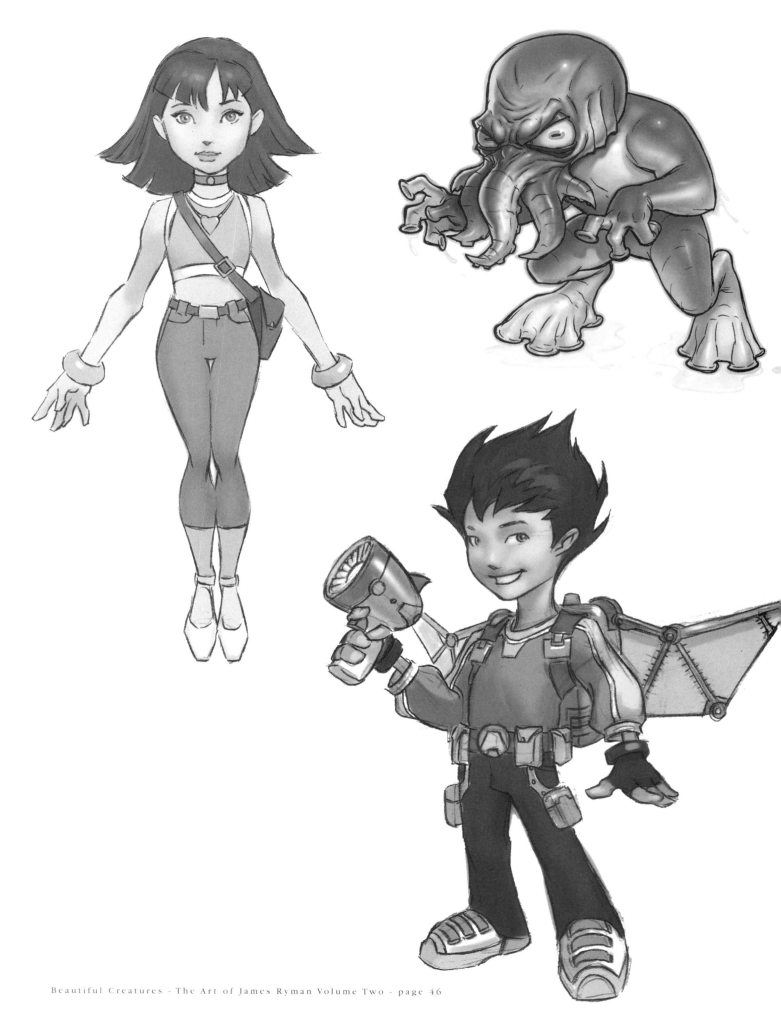

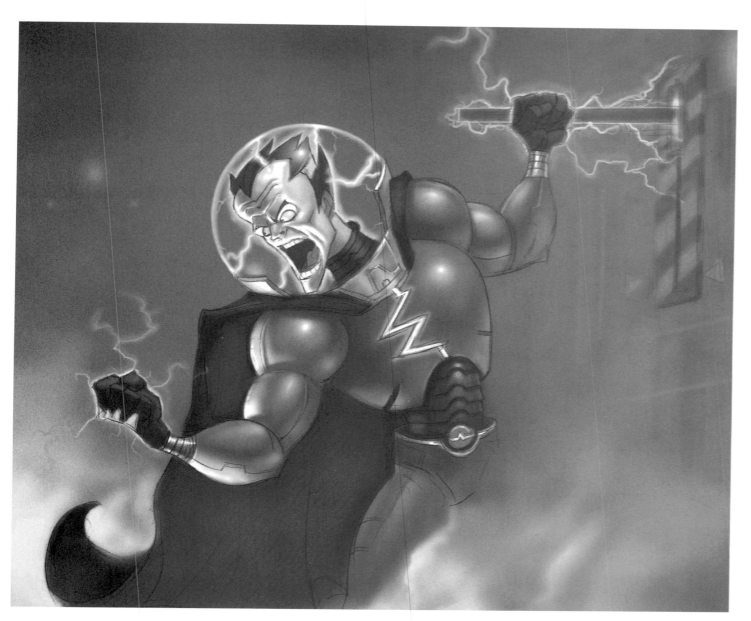

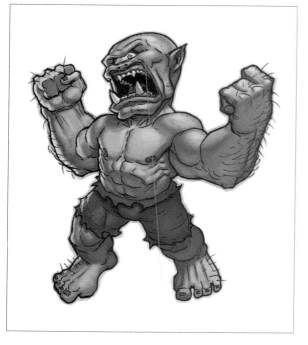

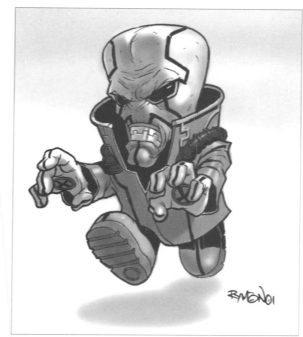

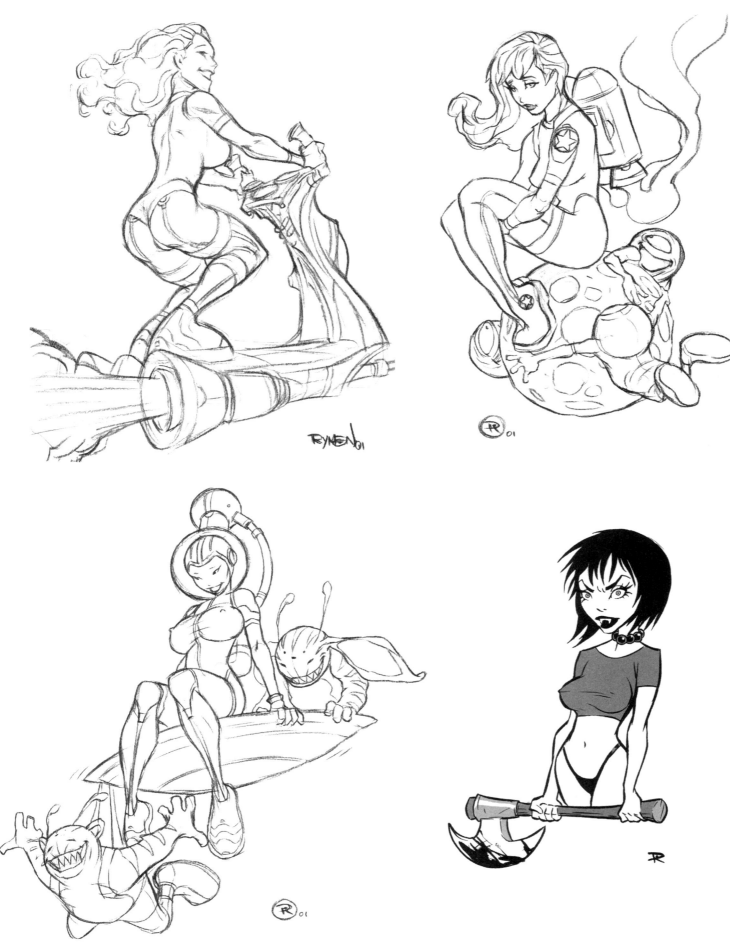

SKETCHES AND CONCEPTS

I often do sketches that I fully intend making into finished art. Sometimes this happens soon after the sketch is made; often an idea can sit around for months (even years!) before I get to it. Regardless, I think sketches can be just as interesting and sometimes more powerful than finished work, and thought I should include some. (I assure you, this section isn't a "filler" for lack of finished artwork.)

More finished pieces are coming in Beautiful Creatures - Volume 3! Soon. Ish.

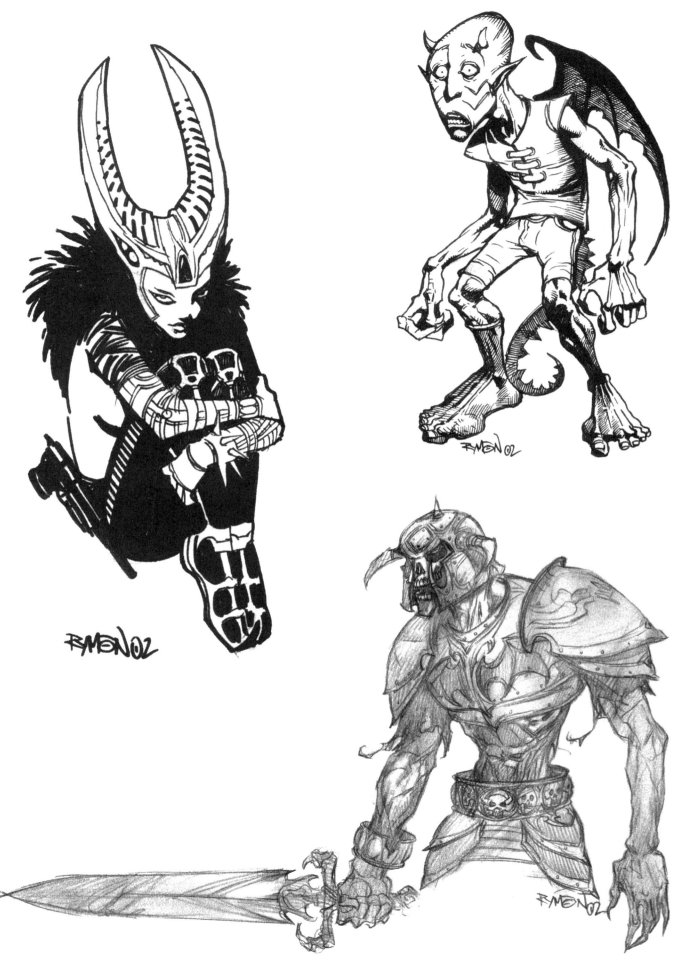

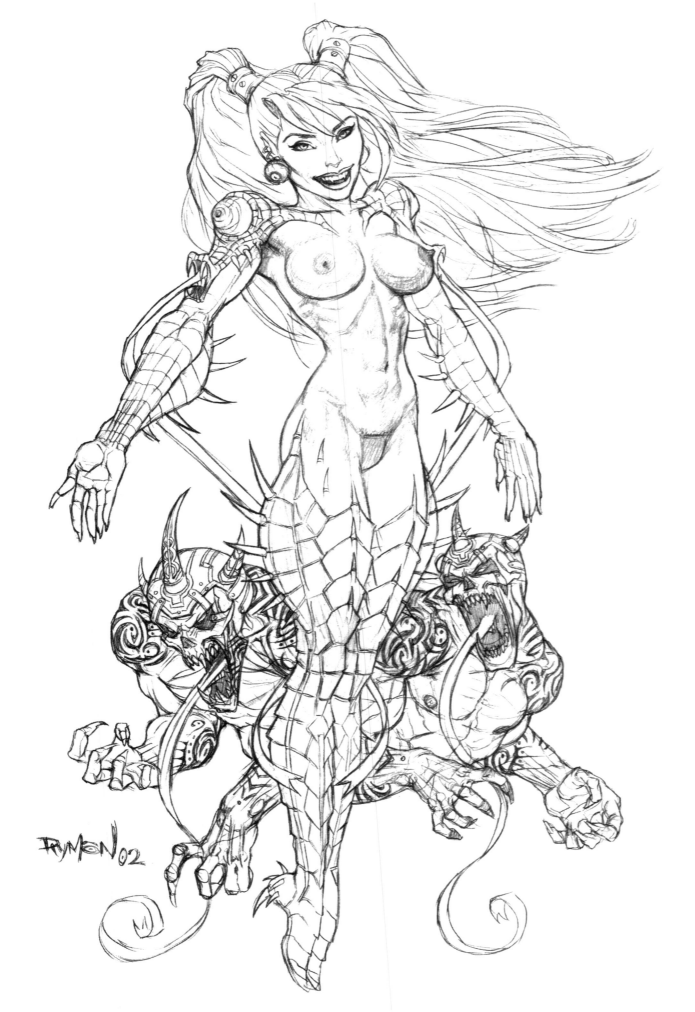

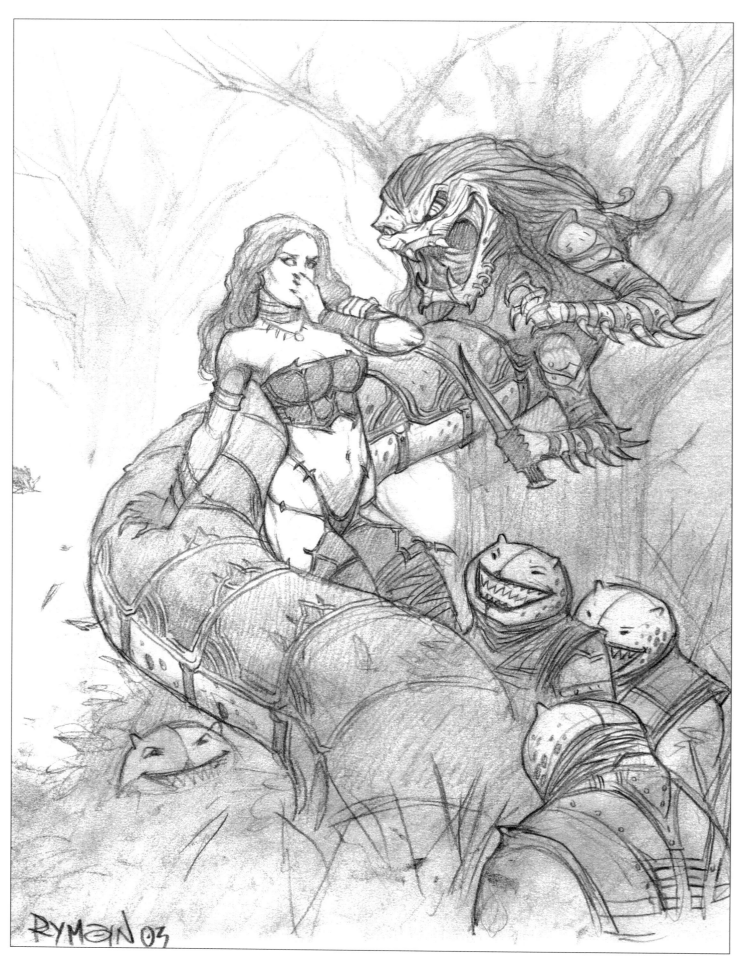

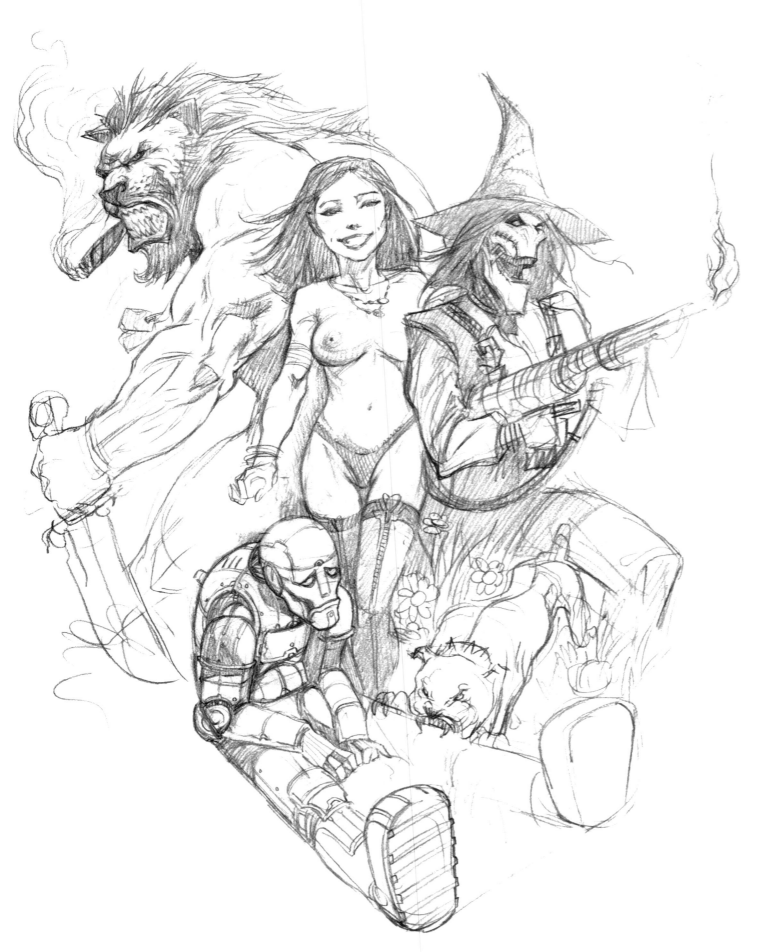

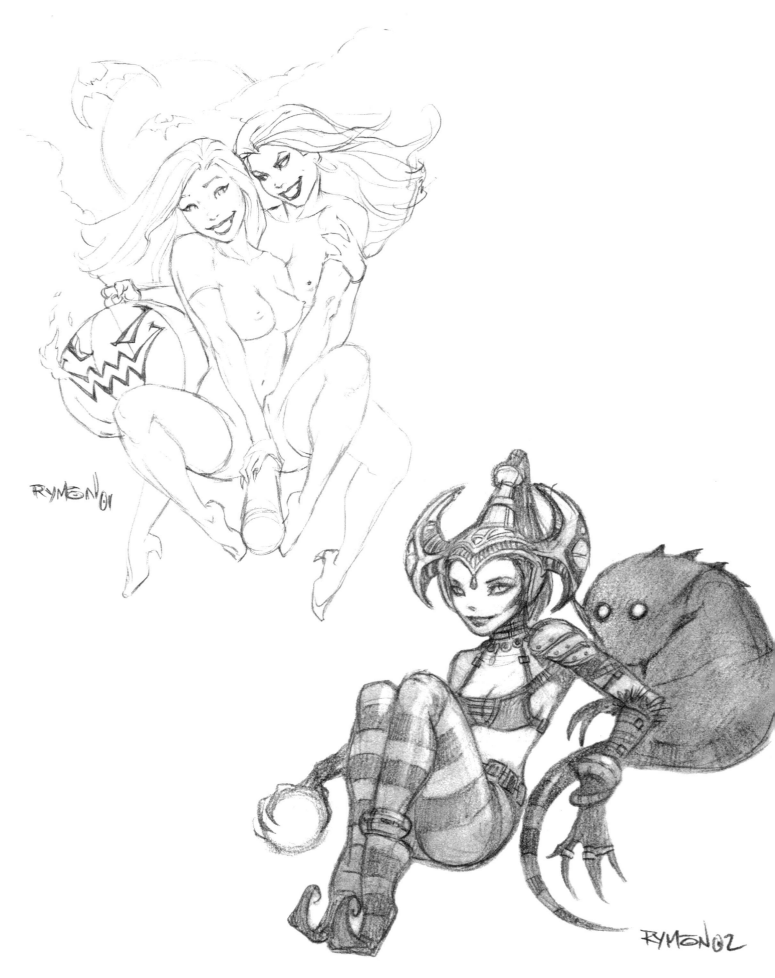

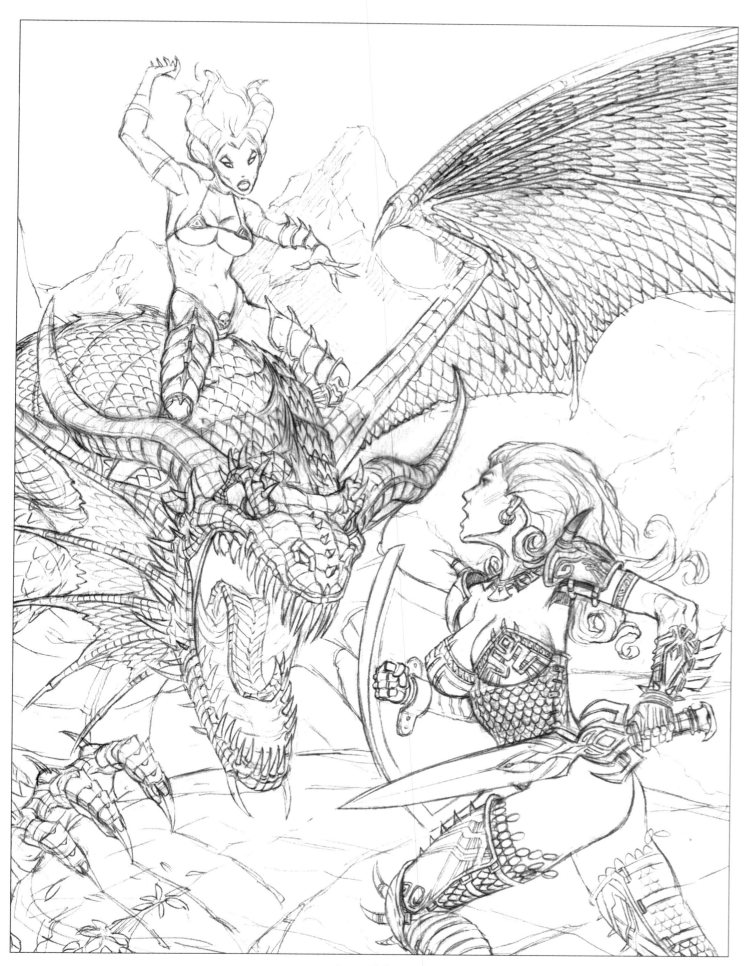

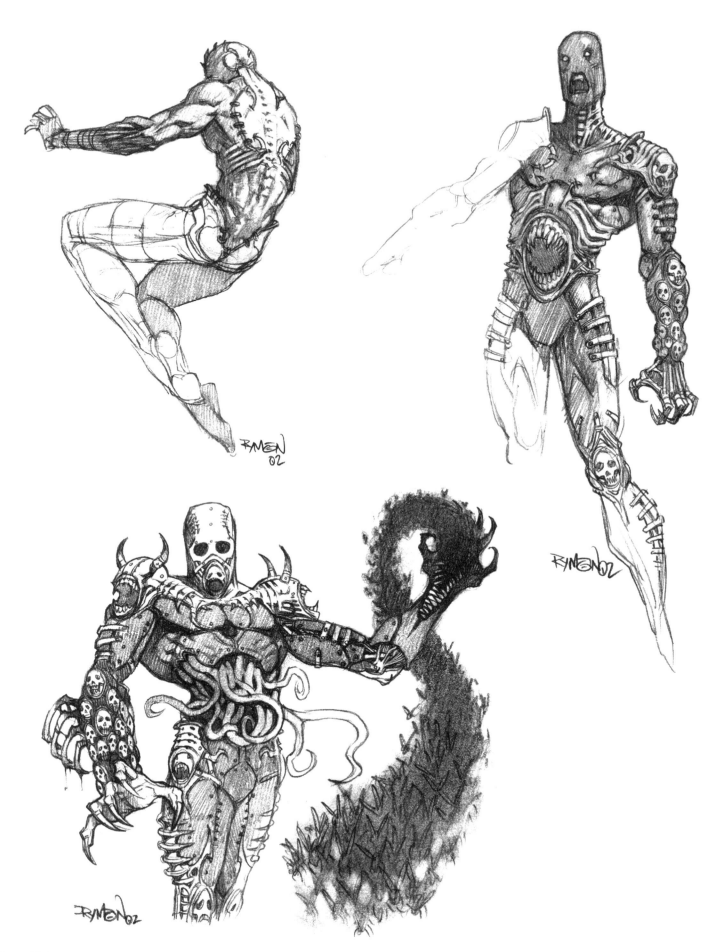

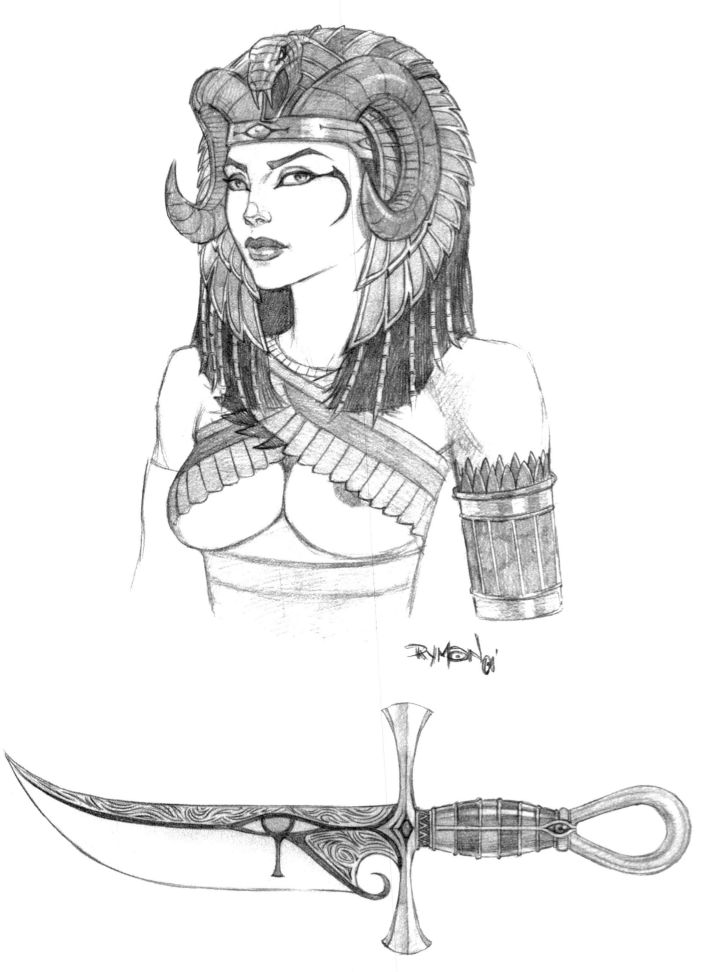

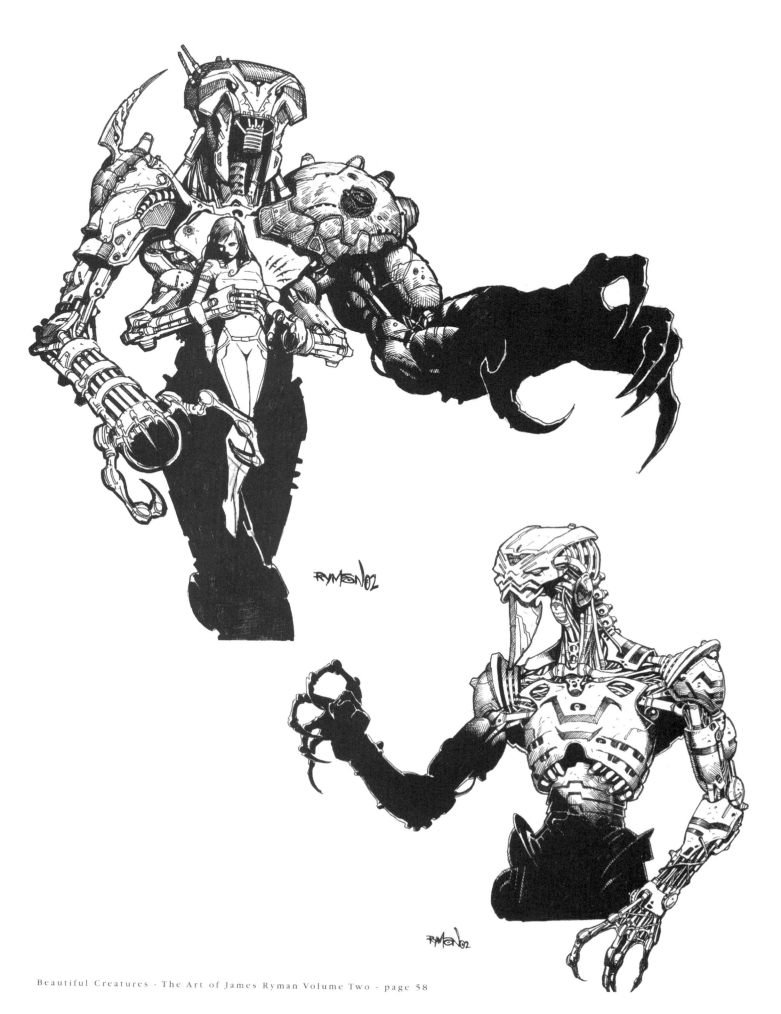

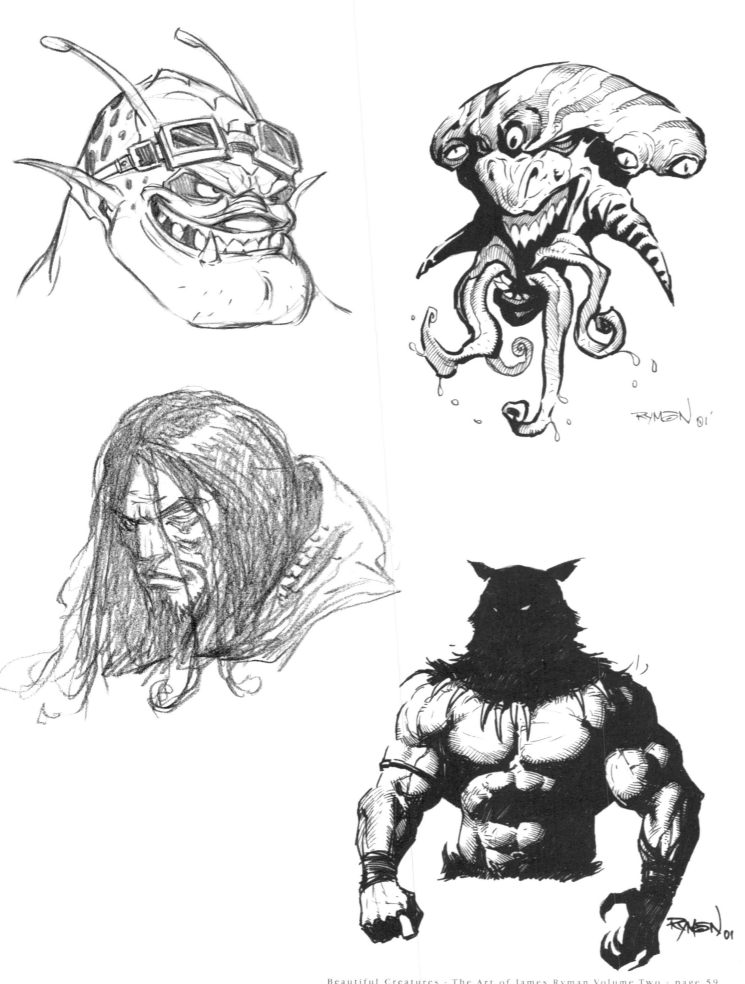

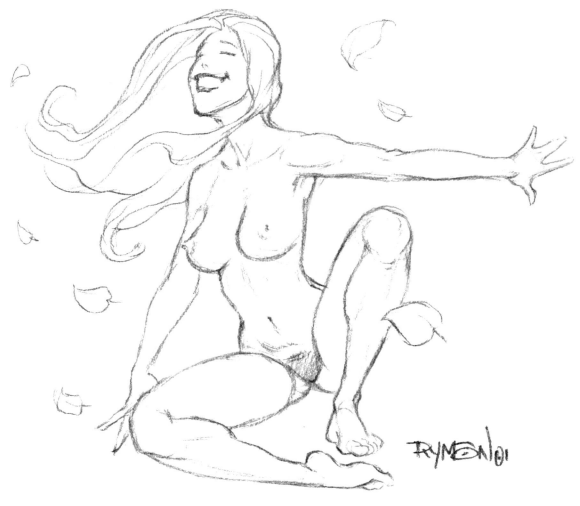

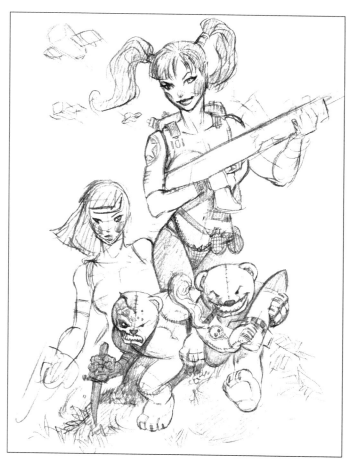

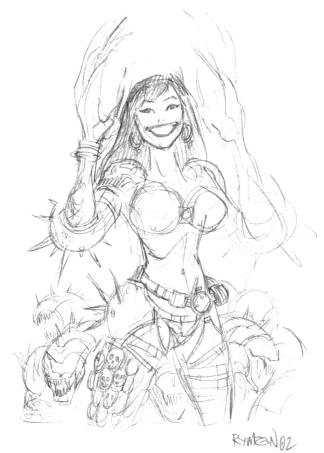

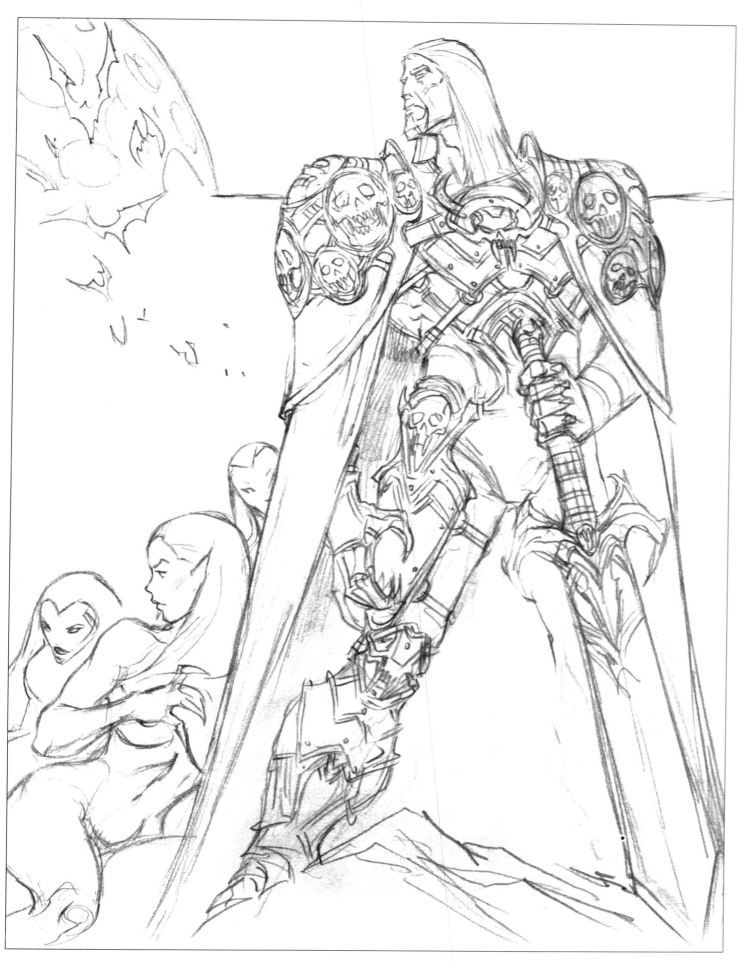

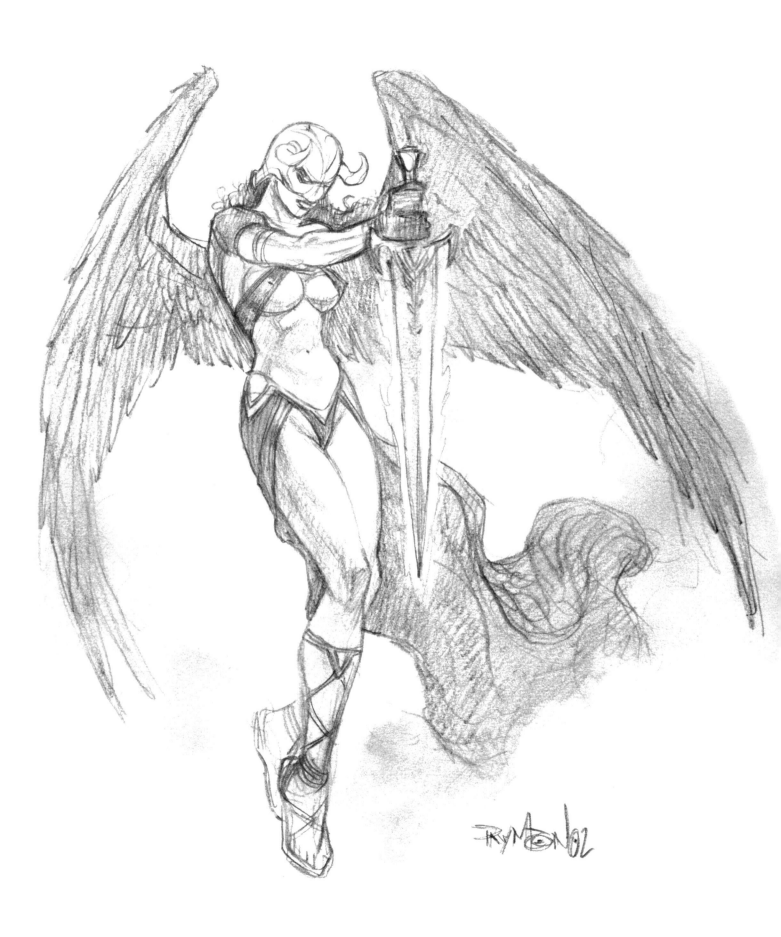

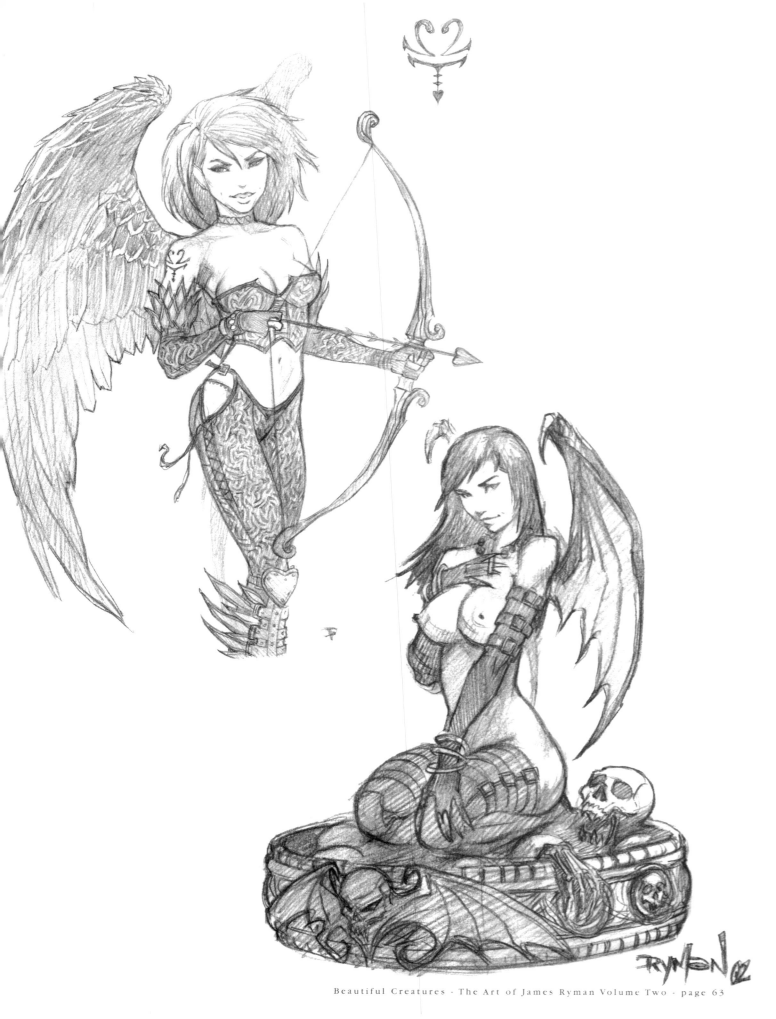

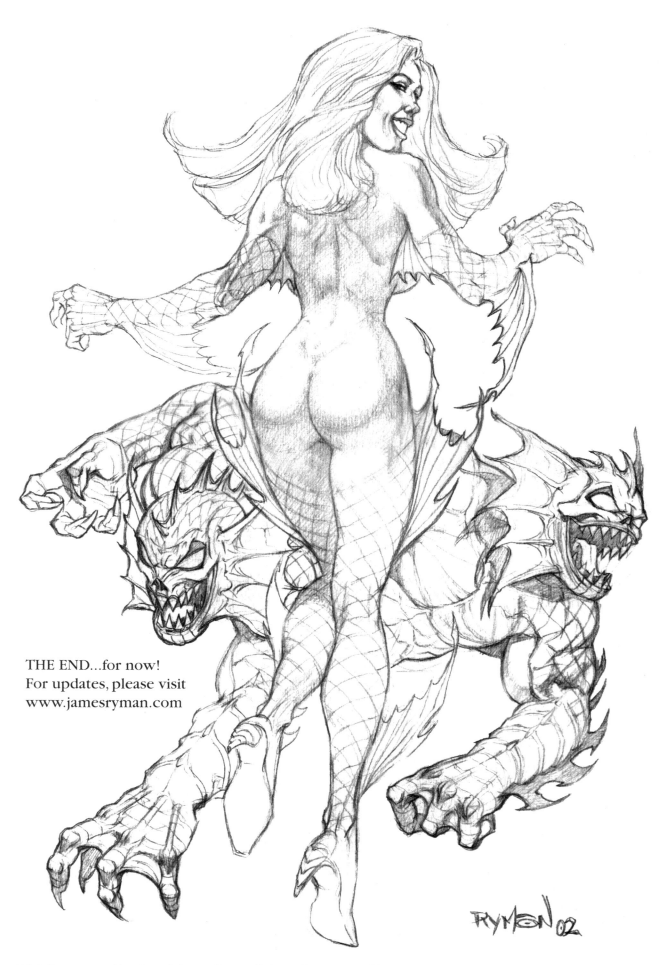

THE END...for now!
For updates, please visit
www.jamesryman.com